IMAGES
of America
BREWING IN BALTIMORE

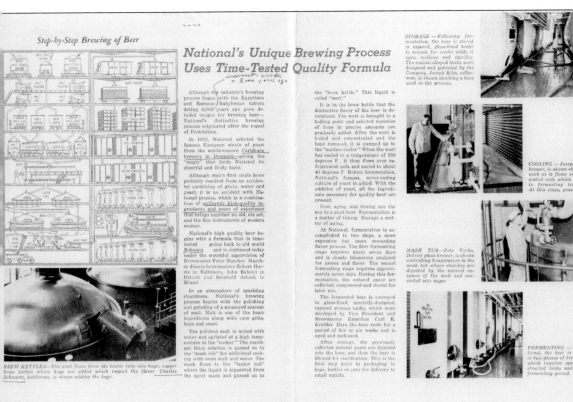

After the repeal of Prohibition, the National Brewing Company flourished. With the reemergence of the brewing industry, interest in the brewing process was also resurgent. This pamphlet was produced by the brewery as part of its marketing program in 1961. The steps in the brewing process are carefully laid out for review. The copy seen here was edited after the fact by a concerned reader. (Baltimore Museum of Industry.)

ON THE COVER: The Globe Brewery was the first in Baltimore to produce real beer after the repeal of Prohibition. The brewery was founded in 1881 and survived the dry years by producing near beer, the only legal beer from 1919 to 1933 in the United States. Just a few minutes after midnight on April 7, 1933, Globe's Arrow Beer trucks were rolling down the city streets of Baltimore, delivering the long-awaited brew. (American Historical Truck Association.)

IMAGES
of America

BREWING IN BALTIMORE

Maureen O'Prey
Foreword by Hugh Sisson

ARCADIA
PUBLISHING

Published by Arcadia Publishing
Charleston, South Carolina

Printed in the United States of America

Library of Congress Control Number: 2011928295

For all general information, please contact Arcadia Publishing:
Telephone 843-853-2070
Fax 843-853-0044
E-mail sales@arcadiapublishing.com
For customer service and orders:
Toll-Free 1-888-313-2665

Visit us on the Internet at www.arcadiapublishing.com

*This work is dedicated to all of the brewers in and around Baltimore
since 1748 and all who have enjoyed the fruits of their labors.*

CONTENTS

FOREWORD

As I grow older I become more nostalgically aware of my predecessors. When it comes to beer, that's a very good thing. In this era of the macro-brew—where one company alone controls almost 50 percent of the American market—it is especially refreshing to reacquaint oneself with the unique characters who added so much color and character to my Baltimore home.

Beer and brewing is a history more of people than product from both a cultural standpoint and an economic development standpoint. To fully appreciate this, think Jerry Hoffberger and the Baltimore Orioles. Think Chuck Thompson and "ain't the Boh cold!" Just two of the more recent examples of beer culture helping define a city as a whole. In the instance of National Brewing, one could even argue that beer defined the entire region—think "Land of Pleasant Living."

Today, Baltimore—and, indeed, the nation—is experiencing a small brewing renaissance. As we celebrate the many new brewers, brands, and beer styles, and incorporate them into the fabric of our daily lives, we are only just beginning to understand the importance these local brands bring to our collective civic pride and identity. Where this will ultimately end up no one can say at present, but this development definitely puts a spring back into our collective step. In many ways this new brewing renaissance is more about the reemergence of local beer culture David in the face of a dominant national beer brand Goliath. It somehow becomes personal.

However the chips fall, I enjoy learning something about those unique individual brewers who came before me. How did they see our city? What did they do to carve out their niche? What were they like as people? In my imagination, I find myself wishing I could sit and have a beer (and maybe crack some crabs or catch a ball game) with many of these folks and compare notes. While that may not be possible, this book may be the closest I will ever come to having that opportunity. Enjoy.

—Hugh Sisson

ACKNOWLEDGMENTS

This project would never have been possible without the faith, support, and encouragement of my husband, Chris, my daughter, Paige, and my sister, Tina. Catherine Scott of the Baltimore Museum of Industry was instrumental in helping bring this together. Many thanks are extended to Mark Duerr of the Zion Church for his enthusiasm and contributions to this project. Thanks are also owed to Cindy Truitt, Jesse Guercio, Jeff Smith, and the crew from Humanim for opening their doors and providing essential information on the American Brewery renovations. Additionally, much gratitude is due to Hugh Sisson, founder of Clipper City Brewing Co. Heavy Seas Beer, for his cooperation and assistance in this project. Interviews and information were also generously provided by Stephen Demczuk of Baltimore-Washington Beer Works and John O'Melia of Bawlmer Craft Beers, who continue the craft-brewing tradition in Baltimore today. Further thanks go out to Lee Young of the American Historical Truck Association, James Long of the Historical Society of Baltimore County, Maria Day of the Maryland State Archives, and Jeff Korman from Enoch Pratt Central Library. Archivists and collections personnel are the oft-overlooked glue that holds any research together, and without them, no project can come to completion. Thank you. A posthumous thank you must also be made to William J. Kelley for his deep commitment to the history of the brewing industry in Maryland.

Images in this volume appear courtesy of the following institutions: American Historical Truck Association (AHTA); Baltimore Museum of Industry (BMI); Baltimore Gas and Electric Co. (BGE); Baltimore Past and Present: Souvenir of the 27th Convention of the United States Brewers Association, courtesy of Mark Duerr and Library of Congress (BPP); Crown Cork and Seal (CCS); Das Neue Baltimore, courtesy of Mark Duerr (DNB); Enoch Pratt Free Library, Maryland's State Library Resource Center, Baltimore, Maryland (EP); Historical American Engineering Record, courtesy of the Library of Congress (HAER); Historical Society of Baltimore County (HSOBC); Library of Congress (LOC); Maryland Historical Trust (MHT); Maryland State Archives (MSA), and the author.

Unless otherwise noted, all images appear courtesy of the Baltimore Gas and Electric Co. Photographic Collection as held by the BMI.

INTRODUCTION

Baltimore town was a small tract of land when it was established in 1729. When John Leonard Barnitz came to Baltimore to found the first brewery in 1748, Baltimore was still a small town surrounded by makeshift fortification walls. Barnitz, like many Baltimore brewers who would follow, was a German immigrant to America. For Barnitz and most of his fellow countrymen, brewing was something that was done in almost every home. Many home brewers made enough for their families on an annual basis and sometimes a bit more to open a tavern or sell to those neighbors interested in more variety.

A handful of breweries would open up in Baltimore in the remainder of the 18th century. Some, like the brewery of Thomas Peters in 1792, would claim to be the largest in the country. Not all breweries succeeded, but the tradition was established, and Baltimore was officially a beer town. These early brewers also had another thing in common: the church and their faith. The Barnitz family and many fellow immigrants helped to found one the earliest churches in Baltimore, Zion Church. This was a Protestant (Lutheran) church in an America that demonstrated religious toleration. Years after the establishment of the Zion congregation, its first church was built on Fish Street in 1762. A host of Baltimore brewers worshiped at Zion Church over the next few centuries, and the success these brewers realized was often invested into Zion Church in one form or another, fomenting the growth of German-language services and, in 1808, a new church building that still stands as Zion Church today.

As the 19th century began, Baltimore town expanded, as did the number of breweries. A variety of brews were produced in Baltimore, including ales, porters, stouts, weiss beer, strong beer (high alcohol), table beer, ship's beer (low quality for sea travel), and small beer (low alcohol). At the beginning of the century, it was estimated that Americans drank 30 gallons of spirits per year, 24 of which was beer. As breweries flourished, so did the technological advancements of the Industrial Revolution. These new technologies infiltrated the brewing industry and had a marked impact on the success or failure of a brewery based upon modernization. As steam power and ice machines changed the face of the brewing industry, the quality of beer increased, producing some of the greatest pre-Prohibition craft beers.

With modernization and quality brews, competition in Baltimore was strong. In addition, most brewers faced another daunting challenge: malt. The early brewers produced their own malt, but by the mid- to late 19th century, most were purchasing it from maltsters in Baltimore. Since malt is one of the primary ingredients in beer, many brewers were mortgaged to their maltsters. All too often, brewers, even those with modernized breweries, would succumb to the debt owed to the maltsters. Those breweries that could not make payments were placed in receivership, and the breweries were either run by the maltsters or sold.

As the 19th century drew to a close, monumental changes came to the brewing industry in Baltimore. Monopolies, or trusts, sprouted towards the end of the century. Many of these trusts were formed to buy a selection of top breweries in Baltimore. Most brewers regretted selling their

plants, as the trust often scrapped and sold the smaller breweries for equipment or changed the brewers and, thus, the recipe that locals were used to. Despite the disappointment, many brewers who did sell made hundreds of thousands of dollars on the sale and opened new breweries to compete with the trust they had sold to. Some were able to buy back their former breweries for half of the cost when the trust failed.

By the beginning of the 20th century, many breweries successfully established themselves as free or independent from the monopolistic brewing trusts in Baltimore. Thus, the battle lines were drawn when it came to producing quality brews. In addition, technology continued to advance. Just a decade prior, new closure devices were created, which raised the quality of the beer that was distributed through the region and beyond. Refrigeration compressors became standard in breweries by the 20th century for quality and efficiency of production. Also, the advent of purchased power became available to industrial businesses in Baltimore. Instead of relying upon steam engines to power the brewery, many were offered the option of buying purchased power from a central utility station. Only a handful of breweries converted to this new power supplier prior to Prohibition.

Baltimore led Maryland in the fight against temperance. Despite the city's best efforts, the 18th Amendment passed, making the country legally dry by 1920. Many breweries closed and sold their equipment. Some attempted to make a legally approved version of beer known as near beer. It was a disappointment compared to the grand tastes of the craft brews Baltimoreans were used to. Most failed, but a handful continued to produce this faux beer until 1933. This dark time in history grew even gloomier when unemployment skyrocketed as a result of the plant closures, which combined with the devastation of the Great Depression.

By 1933, the 18th Amendment was repealed, as it only served to increase organized crime and unemployment and decrease temperance. Those plants that produced near beer were the most prepared for repeal, proceeding to pump real beer out of the plants and into the bars minutes after it became legal. Many new breweries adopted the names of pre-Prohibition breweries to ring a familiar note with the locals, even if the recipe was not the same. Breweries once again began to thrive in Baltimore in the 1930s. New technological advancements aided this, as the American Can Company was the first to create a reliable method of canning beer in which the fizz stayed, keeping the beer fresh for shipping. Many breweries remodeled and chose purchased power to light their plants. This resulted in increased capacity and production.

Not all of these breweries succeeded. Those that did faced heavy competition from the big national breweries like Budweiser. Although the local product was better, the national brands were often cheaper. Those that survived had to alter their production to the changing tastes of America. After World War II, many of our sailors and soldiers were used to the lighter beers that had been shipped in cans overseas. Only a handful of Baltimore breweries survived into the late 20th century.

The last few decades of the 20th century brought large-scale changes to Baltimore's brewing industry, both legislatively and culturally. The last Prohibition-era language was repealed in 1978, when it again became legal for Americans to home brew their beer. By the 1980s, Maryland was pushed to end its temperance-laden laws concerning brewpubs operating in the state. The doors were opened for Baltimore to reconnect with its roots as a beer town. Since the 1980s, Baltimoreans have demanded more locally produced, high-quality brew instead of weak mass-marketed beers. Local brewers met this demand and have firmly established themselves as purveyors of some of the finest craft brews produced in the nation since Prohibition.

When Baltimore town was founded in 1729, it was a plot of 60 one-acre lots surrounded by a stockade fence. In 1748, the Barnitz family arrived in Baltimore to set up the first brewery. They settled near the Jones Falls on the corner of Hanover and Baltimore Streets. The Barnitz family brewed in Germany and had set up breweries in Pennsylvania prior to their arrival in Baltimore. The Barnitz Brewery was Baltimore's first manufacturing industry. The entire operation was run by hand with minimal equipment that included mash tuns, a brew kettle, cooling pans, and fermenting tuns. John Leonard Barnitz died in 1749, shortly after establishing the brewery with his son Elias Daniel, who carried on brewery operations until his own death in 1780. The site continued to be used a brewery periodically over the next 200 years.

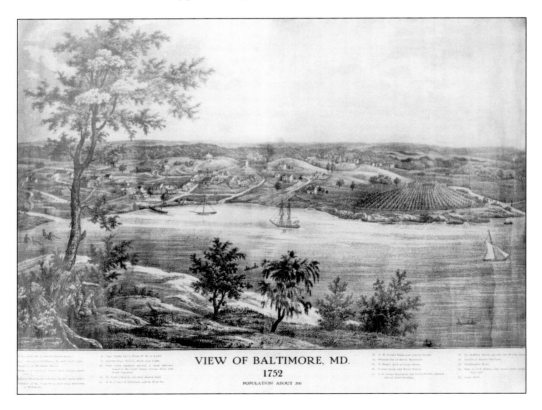

VIEW OF BALTIMORE, MD.
1752
POPULATION ABOUT 300

One

THE FIRST BREWERIES EMERGE
IN BALTIMORE TOWN

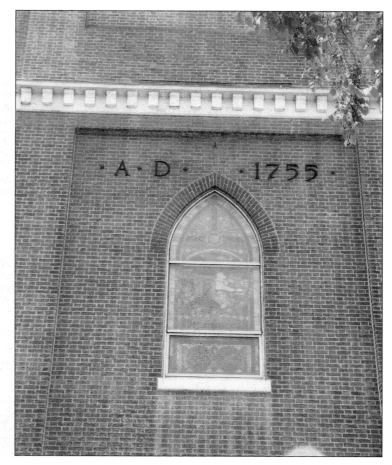

As the number of German immigrants in Baltimore increased, they began to gather together for worship. This group, including Daniel Barnitz, was forced to worship at the Anglican St. Paul's Church in Baltimore, since they did not have a church of their own. Beginning in 1755, Lutheran pastor John Barger would travel to Baltimore from Pennsylvania to lead this small congregation in prayer six times per year. (Author.)

By 1762, the parishioners of the Zion Lutheran congregation built their very first church with their own hands from their own funds. It was a modest weatherboard structure on Fish Street near Gay Street. The congregation was led by Pastor Johann Kirchner when the church opened for services. This small structure was quickly outgrown by the budding German population in Baltimore, and a new church was built in 1808 to accommodate this increase in parishioners. Constructed of stone and brick and featuring fountains and stained glass windows, this new structure was quite grand in comparison to the first Zion Church. This new building was a magnificent house of worship that still stands today on the corner of Lexington and Gay Streets. Since many of the early brewers in Baltimore were German immigrants, most worshipped at Zion. (Both, author.)

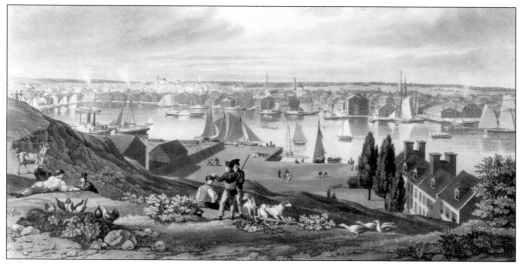

After the Revolutionary War, Baltimore continued to thrive, with its population reaching 40,000 by the War of 1812. One former soldier, Thomas Peters, opened Baltimore's largest brewery at the time near the Jones Falls in 1784. This met with success until it was destroyed by fire on November 21, 1812. Once rebuilt, the brewery was purchased by George Brown on July 14, 1813, forever marking his place in history. In the midst of the war, on August 10, 1813, Mary Pickersgill was commissioned to sew the flag for Fort McHenry. Located just a block from Brown's Brewery, Mary requested permission to complete the sewing of the flag on the floor at Brown's Brewery. At 30 by 42 feet, the flag was too large to finish in her home. George Brown granted permission, and the flag was completed on August 19. (Above, BGE; below, author.)

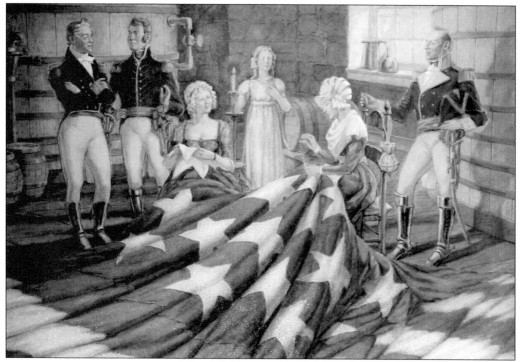

THE STAR SPANGLED BANNER FLAG WAS BORN HERE

★

The flag that flew from the ramparts at Fort McHenry - and inspired the famous poem by Francis Scott Key - was sewn at this site in 1813.

★

In the summer of 1813, Claggett's brewery operated on this property. Mary Young Pickersgill, who lived one block away, was assembling the flag (measuring 30 by 42 feet) by hand and it was too large to sew in her home. She received permission to move the work to the malt house.

Working at night by candlelight, Mary and her small team knelt on the floor to sew 15 white cotton stars - each about two feet across and representing the states in the Union at the time - on English woolen bunting dyed indigo blue.

For her work she received $574.44, paid to her under government contract, for two flags: the large garrison "Star Spangled Banner" flag (measuring 30 by 42 feet) and a smaller storm flag (17 by 25 feet, which has been lost to the ages).

On September 13, 1814, a fleet of 30 British ships bombarded Fort McHenry in an attempt to take Baltimore. As the fort withstood wave after wave of artillery fire for 25 hours, Pickersgill's flag continued to fly. Despite firing between 1,500 and 1,800 rockets and shells at Fort McHenry, the British could not take the fort and were forced to retreat downriver. In all, 4 US soldiers were killed and 24 wounded. The young lawyer Francis Scott Key, held aboard a British ship during the bombardment, was so inspired by the sight of the flag that he wrote the "Star Spangled Banner." This ultimately became the country's national anthem in 1931. In 1818, after limited success, Brown sold the famous brewery to Eli Claggett, a former soldier who was wounded during the bombardment of Fort McHenry. Unfortunately, posterity has often given credit to the McHenry veteran Claggett for owning the brewery in 1813 when Mary Pickersgill sewed the flag, despite evidence to the contrary. (Author.)

14

Two

Breweries on the Rise in the 19th Century

Like his predecessors, Jacob Seeger came from Germany to Baltimore in 1830. A member of Zion Church, he entered the brewing business in 1854. He only produced lager (aged) beer, which had become popular in the States by the mid-19th century. Seeger was quite successful and continued to expand his plant. Since he produced his own malt, the facility needed to be larger than many at the time. (BPP.)

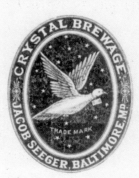

JACOB SEEGER'S

LAGER BEER

CRYSTAL BREWAGE · JACOB SEEGER, BALTIMORE, MD. TRADE MARK

BREWERY,

Cor. W. Pratt & Frederick Ave.,

BALTIMORE, MD.

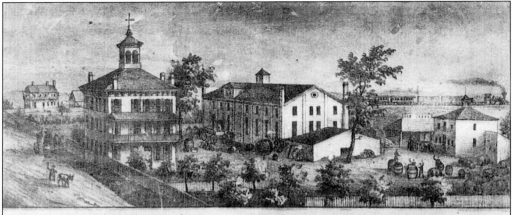

JOHN BAUERNSCHMIDT'S LAGER BEER BREWERY FOOT OF RIDGELY ST.

BAUERNSCHMIDT & MARR

BREWING CO.,

SPRING GARDEN BREWERY,

FOOT RIDGELY STREET,

BALTIMORE.

John Bauernschmidt was one of three brothers who came to America from Germany to found breweries. John settled first in Cincinnati, working for Christian Morlein Brewery, and in 1856 arrived in Baltimore, where he started a brewery of his own. He quickly sold it to go into business with his brother George. After a few short years, in 1866, John once again set off alone to produce lager beer. His brewery on Ridgley Street was quite successful, and he was able to expand the facility to 22,000 square feet. He also included a beer garden and saloon by 1876. In 1879, John died, and his widow brought her brother John Marr in to run the plant, thus renaming the plant Bauernschmidt and Marr's Spring Garden Brewery. (Above, EP; left, BPP.)

Under Marr's leadership, the brewery thrived, by some accounts earning $75,000 to $100,000 annually. The standard practice for brewery owners in the 19th century was to house workers at the brewers' home. Bauernschmidt constructed a three-story home to accommodate the workers, and Marr continued the tradition. Upon proving he was a successful businessman, in 1889, Marr sold the brewery, pictured above in 1980, to venture into the malt business. (MHT.)

The 1860 census lists John Ramming's occupation as brewer. Ramming, like many of his brethren, moved from Germany to Baltimore in 1854. In Baltimore, he ran a small farm with his wife, Katherine, on Abbottston Street where he brewed small beer for private consumption. Once he built a storefront and home at 2607 Harford Road, Ramming increased the amount of beer produced for home use and public sales. (BMI.)

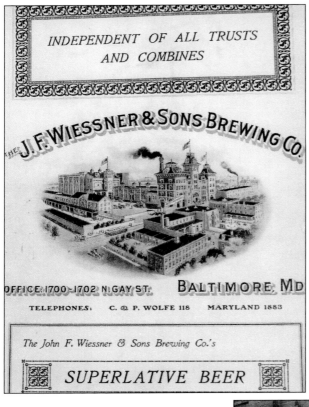

INDEPENDENT OF ALL TRUSTS
AND COMBINES

THE J.F. WIESSNER & SONS BREWING CO.

OFFICE 1700-1702 N.GAY ST. BALTIMORE MD

TELEPHONES: C. & P. WOLFE 118 MARYLAND 1883

The John F. Wiessner & Sons Brewing Co.'s

SUPERLATIVE BEER

John Frederick Wiessner started his brewery in 1863 on a property he leased on North Gay Street. Wiessner, born in Bavaria, secured funding from his family in Germany to build his brewery, the largest one in Baltimore at the time. The brewery had an icehouse, boiler room, storage area, cooperage, stables, cellars, and quarters for brewery workers. In 1880, King Gambrinus, the mythical god of beer and brother to Bacchus, god of wine, was brought to the brewery as a symbol of luck and success. This pewter statue, created in Switzerland, was truly a good omen for the brewery. In 1882, Wiessner brought his son into the business and produced around 20,000 barrels per year. The brew was of the highest grade, demanding $2 more per barrel than any other beer in Baltimore. (Left, BMI; below, BGE.)

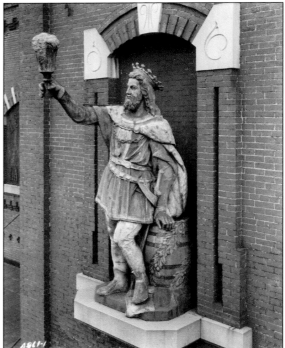

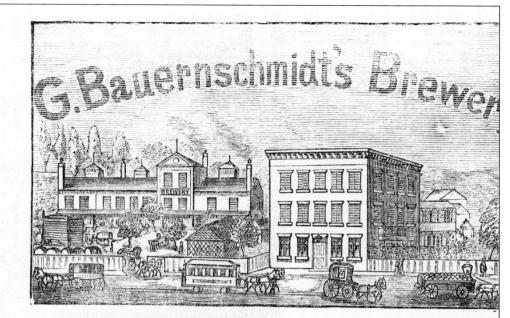

George Bauernschmidt, born in Bavaria, Germany, immigrated in 1853 to Baltimore, where he
worked for brewer George Rost. After learning the trade, he went into business with his brother
John on Pratt Street in 1860. That dissolved quickly, and George leased 12 acres of land facing
Bel Air Avenue, formerly Greenwood Estate, for $750 per year. Initially, George Bauernschmidt's
brewery was a small-capacity lager beer operation producing 5,000 barrels per year. Rather quickly,
Bauernschmidt realized the need to expand. He added a tavern and hotel by 1876 and an addition
to the brewery house by 1879. To remain competitive, however, Bauernschmidt knew he had to
embrace the latest technological advancements in the brewing industry at that time. (Above,
MHT; below, EP.)

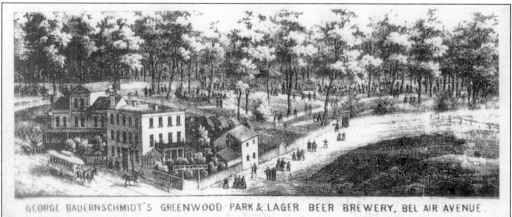

GEORGE BAUERNSCHMIDT'S GREENWOOD PARK & LAGER BEER BREWERY, BEL AIR AVENUE.

GEO. BAUERNSCHMIDT'S GREENWOOD PARK LAGER-BEER BREWERY.

Among those Brewers of this city, who have gained a wide reputation, we may appropriately mention MR. GEORGE BAUERNSCHMIDT, who established business in 1864. A brew-house with all the modern improvements, two double-lined Ice machines with a capacity of one hundred and fifty tons, stables for 60 fine draft horses, and several other buildings are used in the manufacture of a beer which gained an enviable reputation. The yearly product amounts to about 60,000 barrels. A bottling establishment, connected with the brewery, in the handsome building just completed, bottles the beer for family use and the export trade. Three sons of Mr. George Bauernschmidt are employed in the different departments of this vast enterprise.

From 1885 to 1896, several new additions were constructed. George added a steam engine and a refrigeration compressor with 50-ton capacity instead of using ice machines. He was only the second brewer in Baltimore to install a refrigeration machine. This increased capacity left more available storage room. He quickly outgrew the refrigeration machine and added one with a capacity of 100 tons, a refrigerated warehouse, and a bottling plant. By this time, George had purchased the once-leased property and was now fronting Gay Street. He employed all three of his sons at his brewery. By 1895, he ran the largest brewery in the city and was producing more than 60,000 barrels per year. Once he incorporated, this became one of the first stock breweries in Baltimore. He sold the brewery in 1899, shortly before his death. (Left, BPP; below, MHT.)

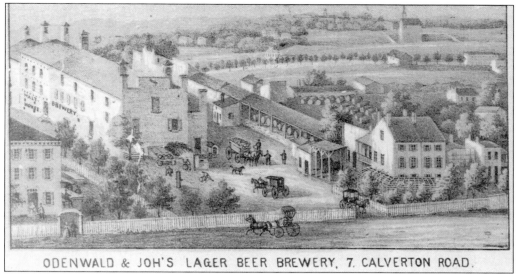

ODENWALD & JOH'S LAGER BEER BREWERY, 7, CALVERTON ROAD.

Philip Odenwald and Ferdinand Joh were German immigrants. After bartending together for a few years, they decided to partner in building a small brewery on Calverton Street. With deep cellars and ice for cooling, they eventually added a malt mill to produce their own malt. They were considered quite successful, producing 4,000 barrels per year until Philip died and his brother-in-law John Sommerfeld purchased his share. (EP.)

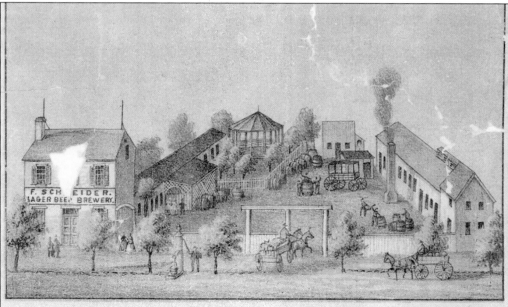

F. SCHNEIDER, LAGER BEER BREWERY COR. 3D & DILLON ST., CANTON.

Frederick Schneider, another emigrant from Germany, started his own brewery in 1864 at 249 Aliceanna Street before quickly moving to Conkling and Dillon Streets in 1866. Schneider was quite successful until his death in 1889. He produced around 3,000 barrels per year and lived comfortably on the proceeds with his family in his home adjacent to the brewery. The brewery was sold in 1892 to the Straus brothers, who also owned the National Brewery. (EP.)

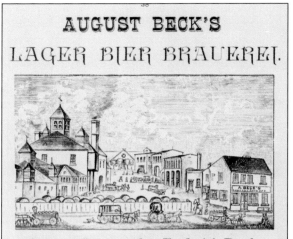

AUGUST BECK'S
LAGER BIER BRAUEREI.

Garrison-Lane, nahe Frederick-Road.
BALTIMORE.

Hr. August Beck uebernahm beim Tode seines Vaters, des Herrn August Beck, sen., die Brauerei und versah dieselbe mit allen den neueren Verbesserungen. Die Baulichkeiten nehmen 140 Front an Garrison-Lane ein und erstrecken sich auf einen Grund Complex der 500 Fuss tief ist. Zwei grosse Eishaeuser geben Lagerraum fuer 12.000 Faesser. Der Umsatz ist zur Zeit von 10 bis 12.000 Fass jaehrlich, ein Umstand, welcher an sich selbst fuer die Guete des Beck'schen Fabrikates spricht: ein vortrefflicher Stall birgt 10 feine Zugpferde.

Im Hintergrund der Brauerei — zwischen schattigen Baeumen — steht ein schoenes Sommerhaus, dessen Waende mit entsprechenden Malereien und Sinnspruechen geschmueckt sind, ein Lieblingswallfahrtsplatz fuer unsere Staedter.

TELEPHONE 1378-3.

August Beck was born in Germany in 1821. He learned the art of brewing in Germany and came to Baltimore in 1854 to work for his brother as a brewmaster. Eleven years later, he opened his own lager beer brewery in 1865. August built several additions to the brewery over the next 14 years in an effort to remain competitive. He enlarged the brew house, built a larger warehouse, a beer garden, and a concert hall, and enlarged his residence to an elaborate three-story redbrick structure to house his family and the brewery workers. Upon his death in 1879, the brewery was turned over to his son August Beck Jr. (Left, BPP; below, MHT.)

August Beck Jr., upon taking over his father's business, attempted to modernize the plant with new machinery. This renovation included an icehouse that could store 12,000 barrels per year. He increased the overall capacity of the brewery to 12,000 barrels per year, although output never exceeded 8,000 barrels. In 1899, with no heirs, he sold the brewery. (MHT.)

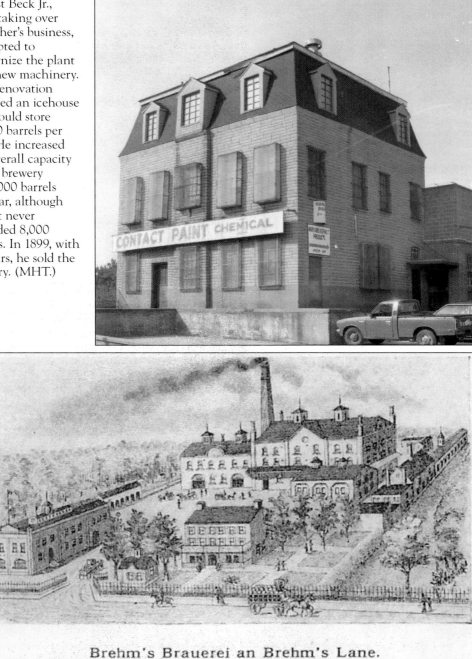

Brehm's Brauerei an Brehm's Lane.

George Brehm immigrated to Baltimore from Bavaria, Germany, in 1864. He came to work for George Neisendorfer at his brewery in Baltimore shortly before Neisendorfer's death. George Brehm married Neisendorfer's widow and took control of the brewery in 1866. Under the leadership of Brehm, the plant increased production from 10,000 barrels per year to 20,000 barrels per year. (DNB.)

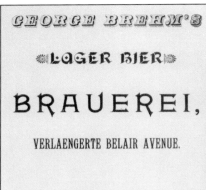

In 1870, a fire broke out and destroyed the wooden brewery built by Neisendorfer. Brehm rebuilt the brewery of brick and enlarged the structure. Not only was the capacity of the brewery greater, but he also added a beer garden, a bowling alley, and a tavern. He continued to expand, adding a refrigeration machine and a bottling plant. In 1899, he was offered $400,000 and sold his brewery to the Maryland Brewing Company. (BPP.)

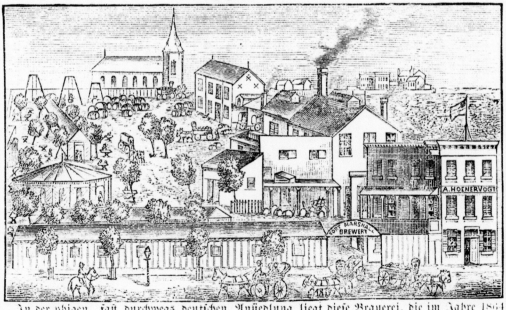

While Brehm was rebuilding, Andrew Hönervogt, brewmaster of the G.F. Weissner Fort Marshall Brewery, married the widow Wiessner and took control of the brewery in 1871. Hönervogt increased the capacity of the brewery on Eastern and Highland Avenues to 8,000 barrels per year with a storage capacity of 4,000 barrels. This allowed the brewery to remain competitive until Hönervogt's death in 1876, when the sons of Wiessner took control. (BMI.)

In 1866, the Straus Malt House was constructed to serve the needs of the growing population of breweries in Baltimore, as most brewers in the 19th century did not produce their own malt. Since malt was a critical component of beer, malt producers had an advantage in Baltimore. Unfortunately, many brewers ended up indebted to their maltsters, and when they couldn't pay, the maltsters would take ownership of the breweries. When the sons of George Wiessner took over the Fort Marshall brewery, they were mortgaged, as were many breweries, to H. Straus Brothers & Co. Malt Manufacturers. Unlike many breweries of the time, the Wiessners paid off their debt and expanded the plant. By 1881, John Wiessner was the only living brother, and he had changed the name of the brewery to John F. Wiessner Lager Beer Brewery. (Above, MHT; below, EP.)

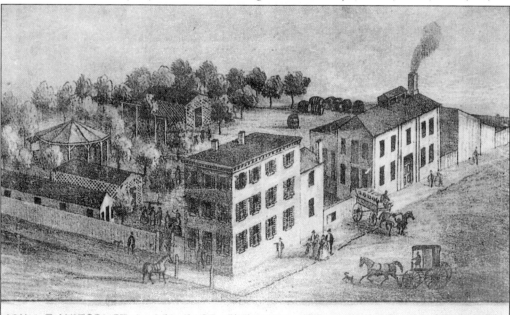

JOHN F. WIESSNER, LAGER BEER BREWERY, COR. HIGHLAND & 2º AVS CANTON

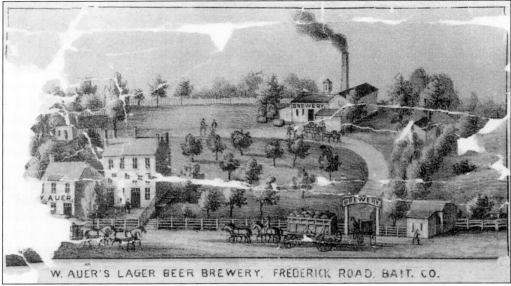

W. AUER'S LAGER BEER BREWERY, FREDERICK ROAD, BALT. CO.

William Auer was born in Germany and worked in many breweries upon his arrival in Baltimore before founding his own in 1867. His brewery, located at Font Hill and Frederick Road, was a perfect location close to Gwynn Falls for potable water. It is unknown if he met with success, as he died in 1872 and his property was seized by the maltster Francis Denmead for unpaid malt bills. (EP.)

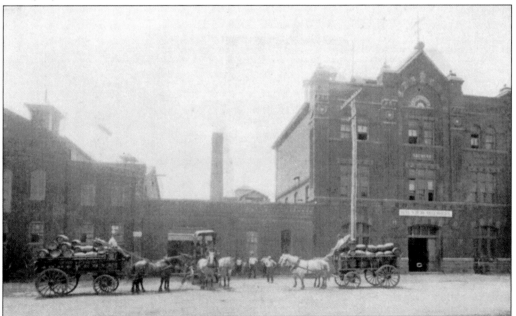

Bayview Brewery was founded in 1867 by a group of German investors. It was the first Jewish-owned brewery and the first to sell stock in Baltimore. Stock breweries of this type became more common in the 19th century. The brewery, located on Eastern Avenue, met with success in the early years, but the lack of modernization and mechanical refrigeration led to its demise. The brewery was sold in 1899. (DNB.)

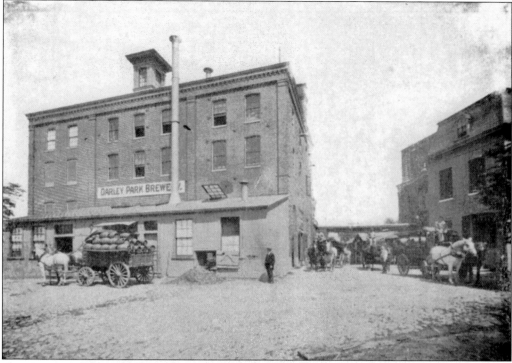

The Darley Park Brewery was originally constructed by George Miller in 1868. When he moved to a different location, Conrad Seigman purchased the property and expanded it to include a 10-pin bowling alley, saloon, and pavilion. In 1873, the property went into receivership to H. Straus Brothers & Co. Malt Manufacturers. Instead of selling, the Straus family ran the brewery, successfully increasing production to 12,590 barrels per year by 1879. John Tjarks, another member of the Zion Church, eventually purchased ownership rights to Darley Park Brewery and added a restaurant. During the 1880s, it was said that Irish moss was cooked in the mash kettle to clarify the beer. Based upon the success of the brewery, this must have been a desired flavor. By 1889, when it was sold, the brewery produced 30,000 barrels per year. (Both, DNB.)

John Tjarks.

FRANZ SCHLAFFER & SOEHNE,

◦ORIENTAL◦

BRAUEREI.

Dritte- und Lancaster-Strasse,

Canton. Baltimore-County.

Herr Fr. Schlaffer gruendete eine Brauerei im Jahre 1872 an Belair-Road, verlegte sein Geschæft jedoch, behufs Geschæftserweiterung nach dem jetzigen Platze

Ecke der Dritten- und Lancaster-Strasse in Canton, Baltimore-County,

unter Mithilfe seiner Sœhne Carl und Georg Schlaffer. Das Brauhaus ist mit allen modernen Einrichtungen versehen, es befindet sich ferner ein grosses Eishaus und Stallung fuer 12 Pferde auf dem Platze. Der jæhrliche Bierumsatz belæuft sich auf circa 10,000 Fæsser. Lagerrænme sind fuer 3000 Fæsser vorhanden.

Franz Schlaffer, a German immigrant to Baltimore in 1830, worked for a number of Baltimore breweries, from Conrad Herzog to George Rost to John Baier, before starting his own. He demonstrated ingenuity as a brewmaster, inventing the swimmers (iron containers holding 100 pounds of ice) to cool the beer in the fermenting tanks. Schlaffer brought this type of entrepreneurship to his Oriental Brewery when he opened. His first brewery in 1872 was a failure due to the lack of potable water. Once he moved to Canton, success followed. He held his beer to a much higher standard than many breweries at the time, including lagering beer longer than average. Schlaffer also embraced the latest technology and installed a new refrigeration system in 1892 in which cold water pipes ran through the fermenting tanks to cool the beer. By 1899, when the Oriental Brewery was sold, it was producing 25,000 barrels per year, had a storage capacity of 4,000 barrels per year, and was complete with a bottling plant of its own. (BPP.)

John Bauernschmidt Jr. was the third of the brothers that emigrated from Bavaria to Baltimore. John began his career working for his brothers before striking out on his own in 1873. He opened the brewery as a one-wheelbarrow brewery with a tiny brew kettle that produced just a half-keg per week. He expanded the brewery to 22 horses by the time he sold it to a foreign investor in 1889. (BPP.)

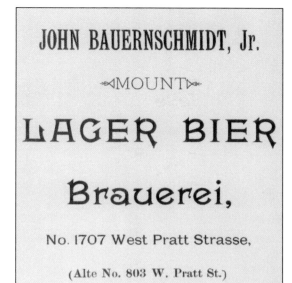

JOHN BAUERNSCHMIDT, Jr.

◄MOUNT►

LAGER BIER

Brauerei,

No. 1707 West Pratt Strasse,

(Alte No. 803 W. Pratt St.)

CORNER OF MOUNT STREET,

BALTIMORE, MD.

JOHN SOMMERFELD'S

Lagerbier Brauerei

und Malzhaus.

Nr. 7 und 9 Calverton-Road.

Die Sommerfeld'sche Brauerei besteht schon seit dem Jahre 1852 und nimmt ein Areal von 254 bei 500 Fuss ein. Dieselbe ist mit den vortrefflichsten Einrichtungen versehen und besitzt ein eigenes Malzhaus, das während des Jahres 25 bis 30,000 Buschel Gerste zu verarbeiten vermag. Besonderer Erwaehnung verdient das mit den neusten Verbesserungen neu errichtete Eishaus ; das alte Eishaus fiel den Flammen zum Opfer.

Mit den auf das solideste hergestellten Braugebaude ist eine hubsche Wirthschaft verbunden. Das Sommerfeld'sche Bier findet nicht allein in der Stadt Anerkennung, sondern hat auch ueber die Grenzen des

John Sommerfeld, a native of Germany, took over the brewery of his former brother-in-law Philip Odenwald. Sommerfeld fared better, as he enlarged the brewery, built his own malt house to try to stay out of debt, and added an icehouse. He reached a capacity of 40,000 barrels per year. Unfortunately, despite producing his own malt, he still went into receivership, and the brewery was sold in 1895. (BPP.)

Henry Eigenbrot,

LAGERBIER BRAUEREI,

28 & 30 WILKENS AVENUE,

nahe Frederick Road,

BALTIMORE, MD.

Herr H. Eigenbrot uebernahm im Jahre 1876 die schoene Brauerei, welche im Jahre 1873 von Herrn Ferd. Joh gegruendet wurde, und versah dieselbe mit den neuesten Verbesserungen.

Auf einem Grundstueck von 200 Fuss Front bei 175 Fuss Tiefe erheben sich die stattlichen Brauerei-Gebaeude, Stallungen, Schuppen u. s. w.

Herr Eigenbrot besitzt ausser einer ausgebreiteten Stadtkundschaft auch auswaertige Abnehmer fuer sein Bier, das sich eines vorzueglichen Rufes erfreut.

The Eigenbrot Brewery was one of the most successful breweries of the 19th century. Henry Eigenbrot inherited the brewery of Ferdinand Joh (former partner to Odenwald) through marriage in 1876. By the time Eigenbrot took over, the facility already included a bottling plant. By 1891, he was producing 14,000 barrels per year. In 1892, the brewery reorganized, and Alexander Straus (of the Straus Malt House) became a partner in the brewery. At this time, the brewery became a corporation and was considered a stock brewery. Straus decided to modernize the plant to include an elaborate boiler house, a refrigeration system, and a compressor house in 1892 (as seen in the photograph below). This was a successful investment, as the production increased to 45,000 barrels per year by 1895. Unfortunately, a fire broke out in the brewery in 1896, causing $65,000 in damages. (Left, BPP; below, DNB.)

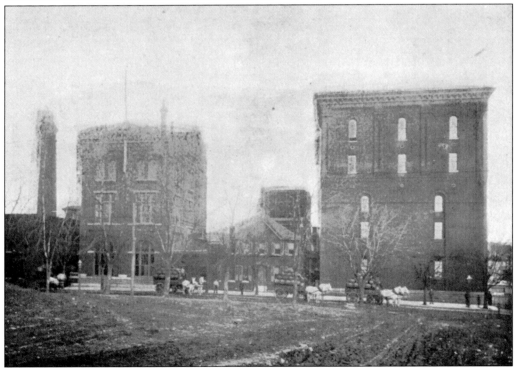

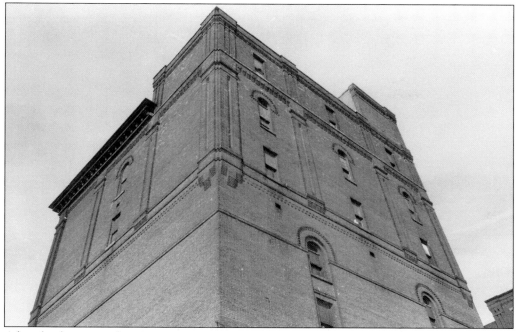

After the fire, a new brew house was constructed to increase production. This was an elaborate five-story brick structure that fronted Willard Street. In addition, a cold-storage warehouse was constructed after the fire to maintain the quality of the beer going to market. Production capacity of the plant reached 100,000 barrels per year after the renovations. Eigenbrot continued to make a consistently high-quality lager beer that was in demand in Baltimore and the surrounding region. The caliber of the brewmaster, Paul Strube, played no small part in the quality of the brew. In 1897, a new, large storage building was constructed to accommodate the production and distribution requirements of the successful brewery (as seen above). This storage building could house 25,000 barrels per year, the largest in the region. (Both, MHT.)

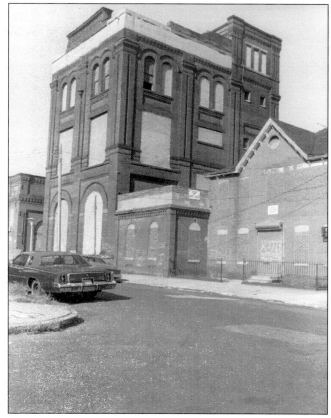

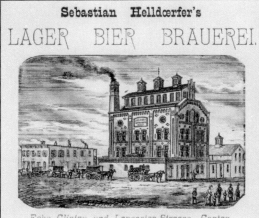

Sebastian Helldoerfer's brewery did not operate nearly at the capacity of Eigenbrot's but shared a similar fate. The brewery opened in 1874, featuring an expansion to the previous brewery that occupied the site. Unfortunately, it was destroyed by fire in 1880. Helldoerfer completely rebuilt with funds provided by his brother. He added a bottling plant and an Eclipse refrigeration machine to bring production to 16,000 barrels per year. (BPP.)

Albion Brewery was established by Frederick Ludwig of Germany in 1848. It changed hands several times until 1877, when it was closed because it was failing and heavily mortgaged. Bernhardt Berger bought the brewery in 1878, paid off the mortgage, and attempted to make a go of it by hiring Frank Molz as brewmaster and installing refrigeration machines. The brewery was successful and was passed to his son in 1893. (BPP.)

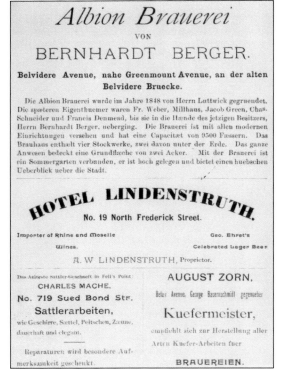

Henry Beck came to Baltimore from Germany in 1867 as a bottler. In 1876, he opened his own Weiss Beer brewery in a small plant on Fayette Street. Weissbier is a pale beer native to Berlin that is fermented after bottling. This beer is only packaged in baked clay bottles with corks, never kegs. The product was limited in demand to the German community but still a successful endeavor. (BMI.)

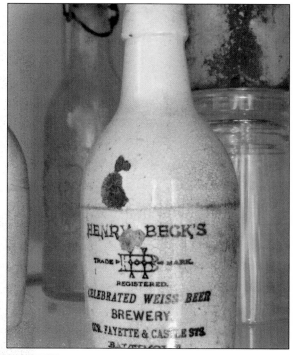

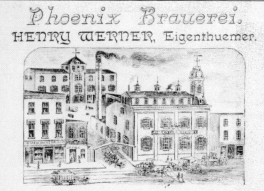

Neue No. 1528, 1530, 1532—1534 Penna. Avenue.

Phœnix Brauerei, vormals John Nagengast & Bros., liegt im nordwestlichen Stadttheile an der Pennsylvania-Avenue, Nr. 1528 bis 1534 und hat eine Front von 120 Fuss bei 200 Fuss Tiefe.

Dieselbe wurde im Jahre 1879 von Hrn. Henry Werner uebernommen und hat sich im Laufe der Jahre zu einem blühenden Etablissement emporgeschwungen. Bei der Uebernahme der Brauerei durch Hrn. Werner, sah derselbe ein, dass Verbesserungen nothwendig waren und hat er dieselben in der praktischsten Weise ausgefuehrt, so dass er jetzt im Stande ist, ein ausgezeichnetes Bier zu liefern.

Besonders zu erwæhnen ist die Ferguson Eismaschine, neuesten Patentes, die sich durch ihre ausgezeichneten Leistungen einen besonderen Namen gemacht hat.

Ferner die beiden neuen Zell'schen Water Tube Boilers, die einzigen, die bis jetzt in einer Baltimorer Brauerei im Gebrauche sind. Der jæhrliche Umsatz der Brauerei belæuft sich auf ungefæhr 18,000 Barrels. 20 Pferde nebst entsprechenden Wagen befoerdern das Gebræu zu den Kunden.

Ein Besuch der Brauerei wird sich fuer jedermann lohnen und an freundlichster Aufnahme fehlt es bei Hrn. Werner nie.

Henry Werner emigrated from Mainz in 1873. In 1879, he purchased a very small brewery on Pennsylvania Avenue from the Nagengast family, who owned the operation. He expanded the brewery, adding an Eclipse refrigeration machine, Zell Water Tube boilers, and three large cellars. Capacity increased to 27,000 barrels annually. Unfortunately, like many of his brewing brethren, he was mortgaged to H. Straus Brothers & Co. Malt Manufacturers and lost the brewery. (BPP.)

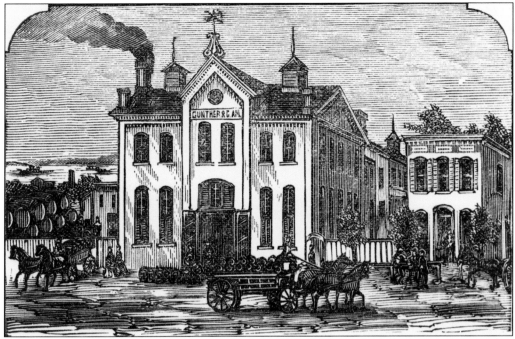

Christian Gehl of Nurnberg started his lager brewery in 1876. He brought in George Gunther as a partner in 1878 to avoid receivership. Gunther bought out Gehl by 1880 and expanded the brewery. In 1886, the brewery burned, so Gunther decided to take advantage of the fire. He hired architect Otto C. Wolf to build a much larger and more advanced brewery that could handle 80,000 to 100,000 barrels per year. This included a five-story brew house. Gunther brought in the most advanced machinery of the time, including a De La Vergne ice machine. He reached a capacity of between 40,000 and 80,000 barrels per year and continued to improve the brewery until 1899, when he sold it for $900,000. George immediately regretted his decision and went into business with his son George Gunther Jr. to compete against his former brewery. (Above, BMI; below, DNB.)

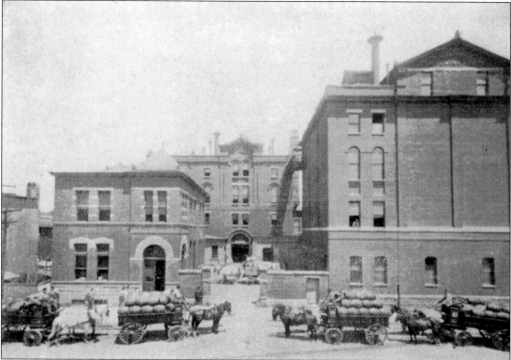

The National Brewery was founded in 1885. It was located in the former brewery of Christian Wunder, which was foreclosed upon by H. Straus Brothers & Bell, Inc. They demolished portions of the brewery to expand and upgraded to the latest technology. They installed a Linde refrigeration machine and increased storage capacity to 10,000 barrels. Sadly, a fire destroyed the plant in 1892. The brewery was rebuilt, making it the "most extensive and completely equipped brewery in Baltimore," according to the *Baltimore American* in 1894. Otto C. Wolfe was the architect. The new brewery, with De La Vergne refrigeration machines, a bottling department, and a 14,000-barrel storage facility, yielded an annual production capacity of 150,000 barrels per year. With Henry Römhildt as the brewmaster, the brewery was only second in beer production in Baltimore to George Bauernschmidt. The brewery sold Bohemian, Bavarian, Pilsner, Brauschweiger, and Mumme. (Both, DNB.)

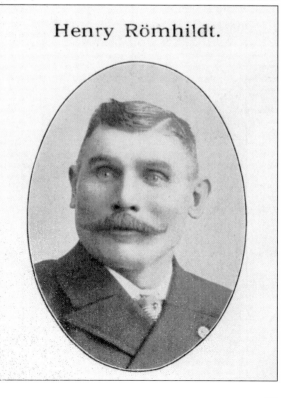

Henry Römhildt.

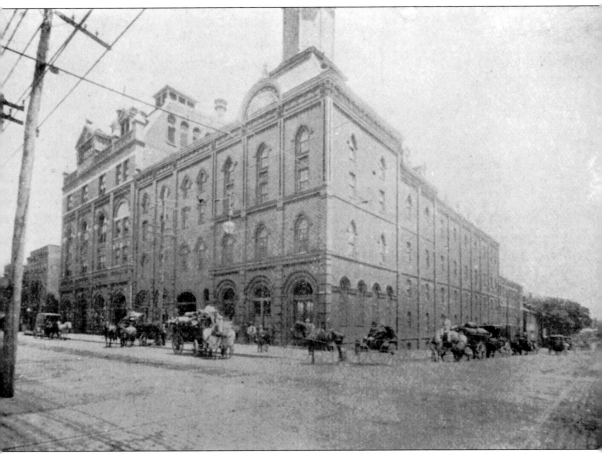

The Globe Brewery was constructed in 1881 on the site of the former brewery of Capt. Joseph Leonard, who founded the brewery in 1815 on Hanover and Conway Streets, presently near the Baltimore Convention Center. The brewery was purchased by Frederick Wehr, Herman Hobelmann, and Frederick Gottleib with the intention of constructing a new malt facility. They instead opened a brewing and malting company on the site. It was a magnificent stone structure that included all the latest technology available in the brewing industry at the time, as well as a refrigeration plant. The Globe Brewing and Malting Company continued to grow and reached a capacity of 120,000 barrels per year, although actual production was around 56,000. The business continued to flourish until 1899, when the company sold the brewery. Gottleib stayed on with the new owners after the sale but was already regretting the decision by 1900. Gottleib carefully continued to manage the brewery until the day he could gain control of the Globe Brewery once again. (DNB.)

In 1891, as technology continued to advance in the late 19th century, William Painter invented the Crown Cork Bottle Closure. The first of its kind, it was patented in 1892. Shortly after realizing the success of his creation, he founded the Crown Cork and Seal Company of Baltimore. Bay View Brewing Company in Highlandtown was the first brewery to use this revolutionary closure to seal in the great flavor and aroma of the beers it produced. Many breweries in Baltimore began using his Crown Cork Closure. To facilitate the use of the closure, Painter invented the foot-powered automated crowner, which allowed operators to fill and cap 24 bottles per minute. This equipment was sold to plants that bottled their own beer. Painter continued to expand his company into one of the largest manufacturing companies in Baltimore. (Right, BMI; below, CCS.)

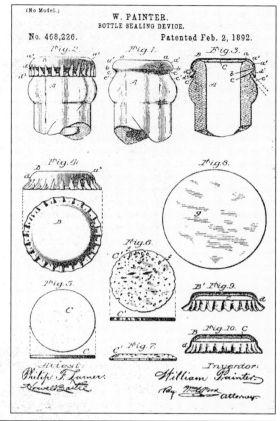

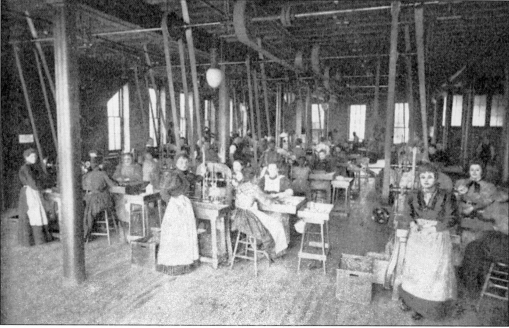

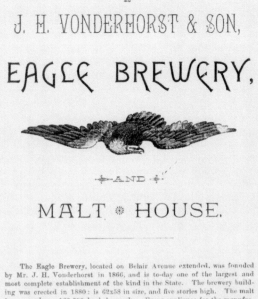

J. H. VONDERHORST & SON,

EAGLE BREWERY,

— AND —

MALT ❋ HOUSE.

The Eagle Brewery, located on Belair Avenue extended, was founded by Mr. J. H. Vonderhorst in 1866, and is to-day one of the largest and most complete establishment of the kind in the State. The brewery building was erected in 1880; is 62x58 in size, and five stories high. The malt house produces 100,000 bushels yearly. Every appliance for the manufacture of pure beer is here to be found, requiring the use of three large steel boilers, and two of De La Vergne Refrigerating Co's latest ice machines. They employ 32 hands; and their stables are filled with 36 of the finest draft horses. The yearly product amounts to 40,000 barrels. In 1880 Mr. Henry Vonderhorst was admitted to an interest in the business, and the firm of J. H. Vonderhorst & Son deserves the success that has crowned their honorable efforts.

John H. Vonderhorst opened his Eagle Brewery in 1866 on Bel Air Road as part of his saloon business. By 1874, he decided to expand into a full brewery complex and brought his son Harry into the business. Harry, who was trained at the Wahl Henius Institute for Brewing in Chicago, was expected to make great contributions to the business. In 1877, deep lagering cellars were excavated, while a six-story malt house, a four-story icehouse, a five-story brew house, a cooperage, and a storage building were constructed. The brewery capacity was 60,000 barrels per year with actual production ranging around 40,000. The malt house produced 100,000 bushels per year. At the time, it was the only plant producing its own malt. The latest mechanical refrigeration equipment (De La Vergne) was also installed to increase production. (Left, BPP; below, BMI.)

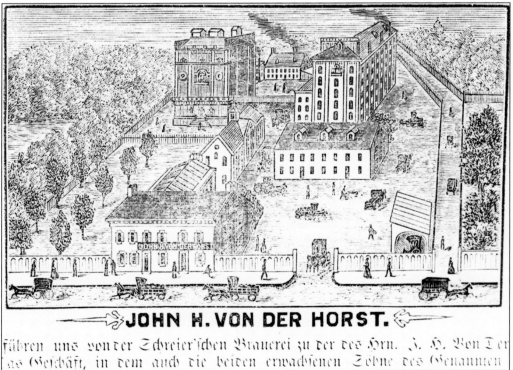

JOHN H. VON DER HORST.

führen uns von der Schreier'schen Brauerei zu der des Hrn. J. H. Von Der
das Geschäft, in dem auch die beiden erwachsenen Söhne des Genannten

The Vonderhorst family was not only famous due to their excellent brew; they were also part owners of the Baltimore Orioles since 1882. Harry spent most of his time building the Orioles into a championship team instead of worrying about the brewery. By 1892, the Orioles became part of the National League, due in no small part to Harry. They had always been a winning team regardless of the league they participated in, but now they were set on winning the National League Championship. Under team manager Ned Hanlon, the Orioles won three championships in a row in 1894 (team seen at right), 1895, and 1896. Sadly, the Orioles never won another championship under Vonderhorst due to business conflicts and were kicked out of the National League in 1900. With John deceased in 1894, Harry Vonderhorst sold the brewery in 1899. (Both, author.)

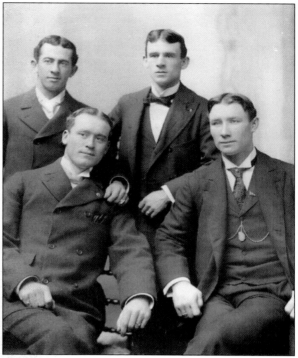

John Marr constructed his malt house in 1890. Marr was the former brewer affiliated with the Spring Garden Brewery of Bauernschmidt and Marr, the Standard Brewing Company, and the Independent Brewing Company. Marr decided that success was to be reached not as a brewer, but in the malt business. John Marr continued to successfully produce malt until 1907. (MHT.)

When the Sommerfeld Brewery went into receivership, it was sold to a group headed by J. Harry Biemiller in October 1895. They named it the Lion Brewery, but it continued to struggle. The brewery changed hands once again, and Kurt Sternberg became manager in 1898. The brewery produced Lowenbrau, pale ale, and Wiener Dark. Lion Brewery had little opportunity for success, as it was sold in 1900. (MHT.)

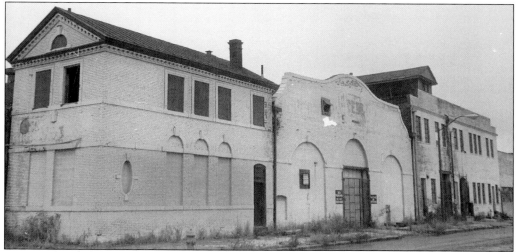

The Moerlein Brewery was a bit unusual for Baltimore in the late 19th century, as it is an expansion of the Christian Moerlein Brewing Company of Cincinnati, Ohio, founded in 1861. The Baltimore brewery dates to 1896. It was located at 1101 South Howard Street. Unusually decorative, it was a sign that other breweries were seeing national success and trespassing on local brewery profits. (MHT.)

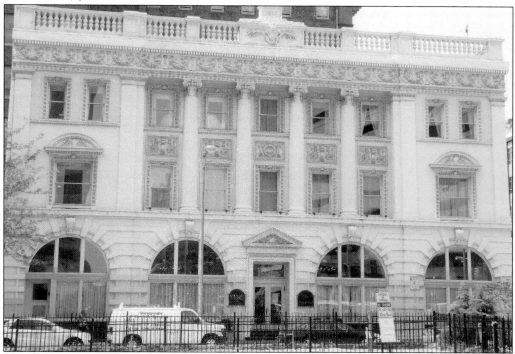

The Brewers Exchange was another end-of-the-19th-century phenomenon in Baltimore. Funded by the Ale and Beer Brewers Guild for securities and commodities negotiation, this had become necessary in an industry flooded with independent brewers and a rise in the number of stock breweries. This would be integral to the industry until the disappearance of independent breweries and the rise of monopolistic national breweries after Prohibition. (Author.)

The Maryland Brewing Company,

OF BALTIMORE CITY.

S. W. Cor. Fayette Street and Park Avenue,

"PATRONIZE HOME TRADE"

Money Sent Out of Baltimore Decreases Local Circulation

The Home Products of the following Breweries are Guaranteed
Pure and Wholesome Lager Beers.

G LOBE BREWERY,
THE NATIONAL BREWERY,
GEO. BAUERNSCHMIDT BREWERY,
GEO. GUNTHER BREWERY,
BAY VIEW BREWERY,
DARLEY PARK BREWERY,

VONDER-HORST BREWERY,
HELLDORFERS BREWERY,
EIGENBROT BREWERY.
GEO. BREHEM BREWERY,
GERMNANIA BREWI

The Maryland Brewing Company was established in 1899. Many of the brewers that sold in 1899 were sold to this trust, totaling 17 breweries in all. Not all of the breweries remained operational once acquired. Often, the smaller or technologically hindered breweries were sold for equipment or scrap. The purpose of the trust was to acquire the top breweries in the city and seize control of the Baltimore brewing market share. This had the potential to wipe out the smaller breweries that did not sell to the trust, as they would be unable to compete. A glimmer of this type of monopolistic activity was seen earlier in 1889, when an English brewing syndicate, Baltimore United Breweries Company, Ltd., earmarked $1.6 million to purchase the top breweries in Baltimore, including little John Bauernschmidt Jr.'s Mount Brewery, the Spring Garden Brewery of Bauernschmidt and Marr, and Darley Park Brewery. These breweries were all sold to the Maryland Brewing Company in 1899. A new century had arrived, along with a new era in the brewing industry in Baltimore. (BMI.)

Three

MONOPOLIES DEVELOP AT THE START OF THE CENTURY

Having the Endorsement of the Best Physicians

EDWIN WALTERS & CO., BALTIMORE,
"ORIENT PURE RYE WHISKEY."
Admittedly WITHOUT A PEER for all Medicinal Purposes.
In Cases and Barrels

The Orient Distilleries, Canton, Baltimore Co., Md.

EDWIN WALTERS & CO.,
35 South Gay Street.

GLOBE BREWERY,

GOLDBRAU—Pale

MUNICH—Dark

Are Lager Beers of Absolute Purity. Rich in Body.

Ripe in Age.

BREWERY,
Block of Hanover, Conway & Perry Sts. Baltimore, Md.

The transition was difficult for many brewers that sold to the trust. Frederick Gottleib stayed on as manager with the Maryland Brewing Company to insure the quality of the product under the new ownership. In addition, the trust did its best to attract locals, as the beer was still locally made. (BMI.)

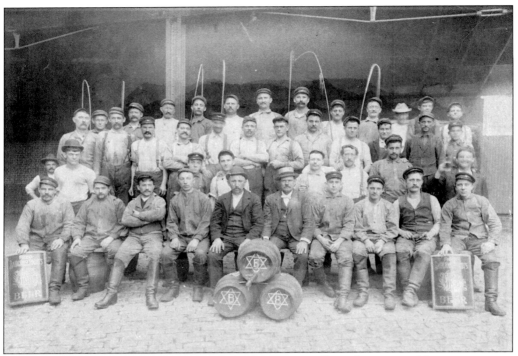

Some brewers could not accept the trust. Fred Bauernschmidt, having conducted the brewing business with his father, George, for a number of years, was incredibly upset that the family brewery was sold and founded his own brewery with the intent of creating such competition that the trust could not succeed. Fred Bauernschmidt's American Brewery was operating by 1900, producing 130,000 barrels per year. Despite not using the latest refrigeration technology (he used ice as a coolant with the deeply excavated cellars), the quality of the Bauernschmidt label was consistent and in demand. He cellared his beer for four months prior to distribution, crafting some of the best lager beer in Baltimore. By 1910, a bottling plant was added to the brewery, and expansion continued. By Prohibition, the Fred Bauernschmidt American Brewery was producing 400,000 barrels per year. (Above, HSOBC; left, author.)

Frank Steil was born in Kirschberg, Germany, in 1865. In 1875, like many fellow countrymen, Steil and his family chose to emigrate from Germany to America. In 1899, he took a position as a bill collector for John Marr's Independent Brewery. Marr's brewery, the former brewery of August Beck, was established in direct response to the corporate trust that purchased 17 of the city's breweries. Marr, along with those breweries that did not sell to the trust, prided themselves on their sole proprietorship and advertised as such to a public that was also leery of the monopoly and whether it would compromise the products many had come to love. Unfortunately, the brewery went bankrupt in 1900. On December 1, 1900, Steil, with money borrowed from Marr's former partner Buxbaum, bought the Independent Brewery. (Right, DNB; below, Duerr.)

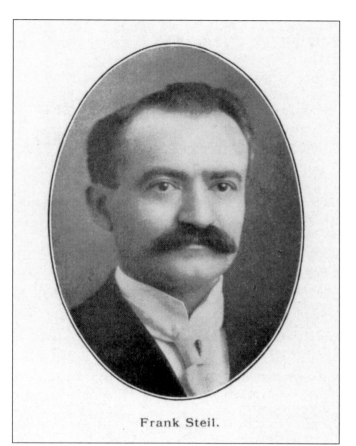

Frank Steil.

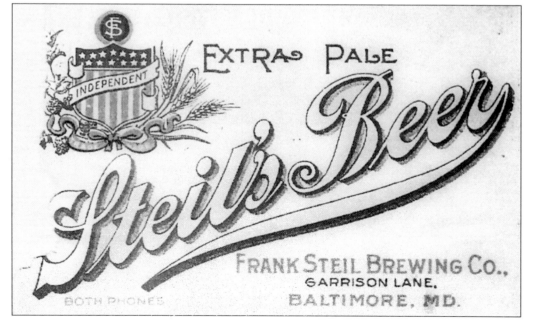

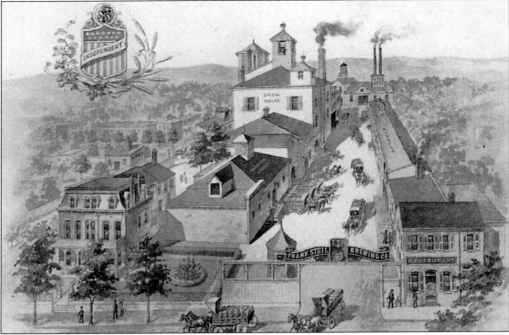

As a response to the consolidated breweries trust, Frank Steil established himself quite purposefully as independent of any corporate ownership. He called his brewery the Frank Steil Independent Brewery. This venture carried a $70,000 mortgage with it and pressure to succeed in a changing Baltimore brewing climate. Steil had a knack for marketing and a firm grasp on what needed to happen for the plant to be successful. By 1903, the brewery had increased capacity to 28,000 barrels per year. He also brought his brother Frederick into the business that same year as treasurer, defining the brewery as family owned and operated. It was a productive decision, and Frederick eventually came to manage the brewery prior to Prohibition. The group photograph includes the Steil and Tjarks families. Tjarks was formerly affiliated with Darley Park. (Above, DNB; below, Zion Church.)

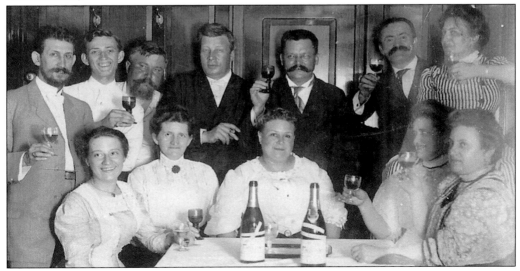

Steil continued to make several improvements to the brewery. By 1906, the brewery's capacity reached approximately 40,000 barrels per year. Steil committed to installing the most modern technology available in the brewery, as well as purchasing available equipment from closed breweries and hiring employees away from the breweries of the failing trusts. Steil completely paid off the mortgage by 1906 and opened his own bottling plant. Prior to this, Philip Brendel was bottling beer for Steil's Brewery. Steil expanded the bottling facility in 1908 and again in 1913. By every measure, Steil was a success. He represented the spirit of the early German brewers in Baltimore as entrepreneurs and competed against the beer monopoly in Baltimore and won, until 1920, when all the breweries were shut down by Prohibition. (Both, Duerr.)

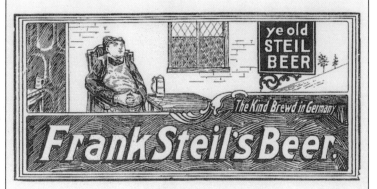

THE BEER

THAT IS BRINGING GREATER BALTIMORE TO THE FRONT

ye old STEIL BEER

The Kind Brewd in Germany

Frank Steil's Beer.

BALTIMORE, MD.

Bottled on Brewery Premises

FOR HOTEL AND FAMILY USE

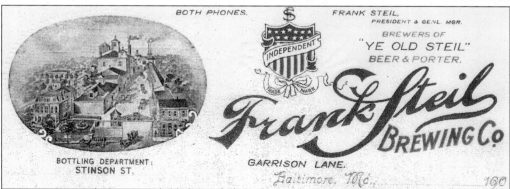

BOTH PHONES.

FRANK STEIL, PRESIDENT & GEN'L. MGR.

BREWERS OF "YE OLD STEIL" BEER & PORTER.

INDEPENDENT

TRADE MARK

Frank Steil BREWING Co

BOTTLING DEPARTMENT, STINSON ST.

GARRISON LANE.

Baltimore, Md.

190

The purchase of 17 Baltimore breweries by the Maryland Brewing Company in 1899 for rather exorbitant sums was not a triumphant venture. The backlash was almost immediate, as the brewery workers, under National Union guidance, quit their jobs on August 3, 1899. Negotiations were quickly reached to limit working hours and raise hourly wages. The strain was still too much for the monopoly, and it began to sell off some of its acquisitions. George Brehm, who initially received $400,000 for his brewery from the Maryland Brewing Company, was able to repurchase his brewery for $185,000. Despite the promise of efficient management, the company defaulted and was forced into receivership in 1901. A new conglomerate was quickly formed between Joseph Straus, Frederick Gottleib, and John Bauernschmidt called GBS, and the breweries were once again part of a Baltimore brewing monopoly. (Both, BMI.)

With a price tag of $3.5 million, GBS had quite a bit of work to do to compete with the independent breweries and produce enough to surmount the debt. Unlike the Maryland Brewing Company, GBS chose to operate the breweries independently and have them pay into the trust. They were all bottled under their own brands with "GBS" added to the labels. This approach, combined with the closing of the low-production plants, proved successful. Much of the equipment from these closed plants was sold or brought to the high-yield plants to aid in production. This consolidation of the Baltimore breweries seemed to work quite well for GBS; however, it is clear from the letter at right that it was not always a smooth transition, and management issues needed to be addressed. (Both, BMI.)

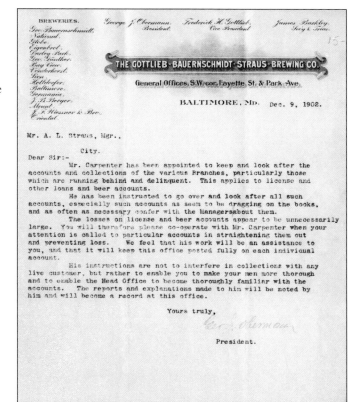

BREWERIES.
Geo. Bauernschmidt.
National.
Globe.
Eigenbrot.
Darley Park.
Geo. Gunther.
Bay View.
Vonderhorst.
Lion.
Hollhofer.
Baltimore.
Germania.
J. H. Seeger.
Mount.
J. F. Wiessner & Bro.
Oriental.

George J. Obermann, President. Frederick H. Gottlieb, Vice President. James Bachley, Secy & Treas.

THE GOTTLIEB · BAUERNSCHMIDT · STRAUS · BREWING CO.

General Offices, S.W. cor. Fayette St. & Park Ave.

BALTIMORE, MD. Dec. 9, 1902.

Mr. A. L. Straus, Mgr.,

City.

Dear Sir:-

Mr. Carpenter has been appointed to keep and look after the accounts and collections of the various Branches, particularly those which are running behind and delinquent. This applies to license and other loans and beer accounts.

He has been instructed to go over and look after all such accounts, especially such accounts as seem to be dragging on the books, and as often as necessary confer with the Managers about them.

The losses on license and beer accounts appear to be unnecessarily large. You will therefore please co-operate with Mr. Carpenter when your attention is called to particular accounts in straightening them out and preventing loss. We feel that his work will be an assistance to you, and that it will keep this office posted fully on each individual account.

His instructions are not to interfere in collections with any live customer, but rather to enable you to make your men more thorough and to enable the Head Office to become thoroughly familiar with the accounts. The reports and explanations made to him will be noted by him and will become a record at this office.

Yours truly,

Geo. J. Obermann

President.

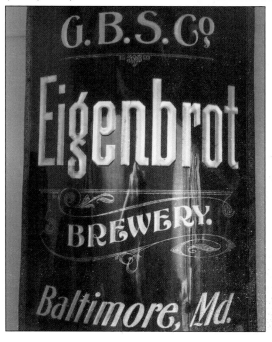

G.B.S. Co.
Eigenbrot
BREWERY.
Baltimore, Md.

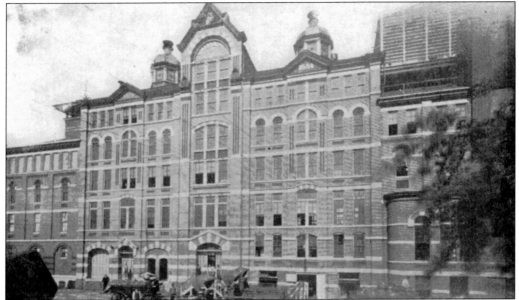

As GBS met with some success, it still struggled against the independent breweries like John F. Wiessner, Frederick Bauernschmidt, and Frank Steil. Having George Brehm and George Gunther also back in the brewing business after initially selling to Maryland Brewing increased the difficulty. However, GBS still had some top-selling beer coming out of the Eigenbrot Brewery (as seen in the ledger below), Darley Park Brewery, George Bauernschmidt Brewery, Globe Brewery, and National Brewing Co. These were the only plants GBS decided to keep operational, as they were the most productive, with name brands that Baltimoreans still demanded despite the affiliation with the monopoly. GBS continued on until Prohibition took effect in 1920. (Above, DNB; below, BMI.)

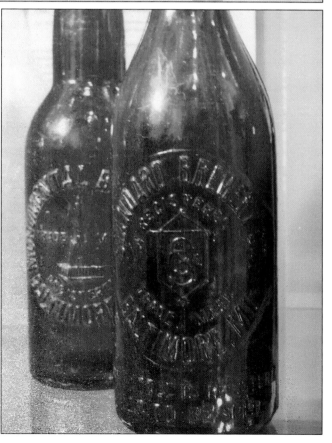

Monumental Beer on Draught
at the
Bar
.. The King of Beers ..
Nuf Ced.

.. Grand Annual Ball ..
— OF THE —
BALTIMORE
Federation of Building Trades,
.. BAVARIAN HALL ..
Monday, December 31st, 1900.

Music, 4th Regiment Band.

Monumental Brewing Co. was founded by William Straus of the National Brewery after it was sold to the Maryland Brewing Company in 1899. He hired Henry Römhildt away from the National Brewery as his brewmaster. Straus also purchased the defunct Monarch Brewery and rebuilt the plant to compete with the brewing trust in Baltimore. It was the first completely modern brewery in Baltimore. Monumental bottled its own beer and had no underground cellars like most Baltimore breweries; instead, each floor of the brewery was equipped with mechanical refrigeration. Straus produced 150,000 barrels per year by 1900 and continued to expand the plant through 1912. He was incredibly successful, and the "King of Beers" was distributed throughout Maryland and the southern United States, reaching an annual capacity of 300,000 barrels by Prohibition. (Both, BMI.)

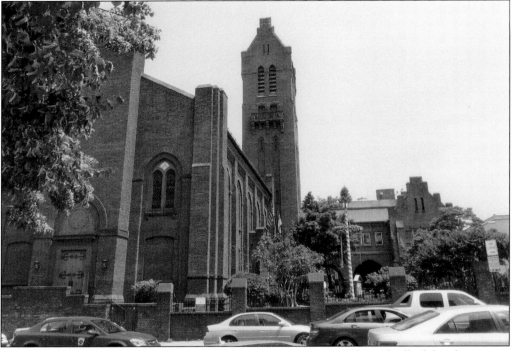

Through all of the changes taking place in the brewing industry in Baltimore during the transition to the 20th century, the one thing that remained unchanged was the commitment of the brewers to Zion Church. Zion Church saw its share of change and turmoil over the previous century, including a split from the Reformed Lutherans and another within the church itself on the issue of introducing English-language services when German had been the only language at Zion. Daniel Kurtz served as pastor for 47 years, guiding his flock through much of the language tumult. A conservative Lutheran in his preaching, he was well supported by his congregation, even when they preferred a more liberal approach in the pulpit. (Both, author.)

Eventually, Pastor Heinrich Scheib came to Zion by way of Germany and New York. Scheib embraced the liberal approach of a European Lutheran pastor and fit right in at Zion. There were a few natural disasters and some dissention in the ranks as Scheib espoused a mix of liberal ideas, a bit of mysticism, and strong Lutheran tradition. Scheib and his parishioners rallied through it all, including the transformation of the Zion School, to which the bell at right belonged. Reorganization at Zion began with educational philosophy. Pastor Scheib fully embraced scientific, rational learning combined with a holistic approach to develop the whole child. The school was imminently successful and saw a maximum enrollment of 802 students, even during the Civil War. Of further note is the fact that the majority of students were Catholic, Jewish, Anglo American, and non-Zion German Protestants. (Both, author.)

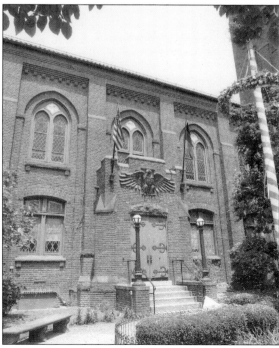

Zion pastors like Pastor Scheib had the honor of performing marriage ceremonies for some of these distinguished brewers, such as George Bauernschmidt and his wife, Margaretha. The Zion brewers, like many Zion parishioners, gave back to the church by donating funds to rebuild, enrolling their children in the school, or funding dedications, as seen at right. Another famous Zion brewer who fought the brewing monopoly in Baltimore was John. F. Wiessner. John and his wife, Sarah, donated the stained glass window shown below. Still seen in Zion Church today, this window flanks the left side of the altar. Steil also donated an altarpiece that is still used today. The brewers of Zion are intrinsically linked to the history of the church and serve as a proud reminder of the German tradition of both Lutheran worship and the foundations of brewing in Baltimore. (Both, author.)

The Great Baltimore Fire began in the basement of the John E. Hurst building on German Street on February 7, 1904. The fire swept eastward to the Jones Falls, taking out the majority of Baltimore's downtown business district by the time it was extinguished on February 8, 1904. The fire spanned 140 acres, destroyed 1,500 buildings, and closed 2,500 firms, putting thousands out of work. Economically, the fire was devastating, with an estimated loss of between $125 million and $175 million. Sadly, the former Brown's Brewery, once the site of the sewing of the Star Spangled Banner Flag (later Claggett's Brewery) was destroyed in the fire. What is noteworthy is the number of breweries that did not burn in the great fire. Due to their location, most Baltimore breweries were just outside of the perimeter of the fire and escaped any damage.

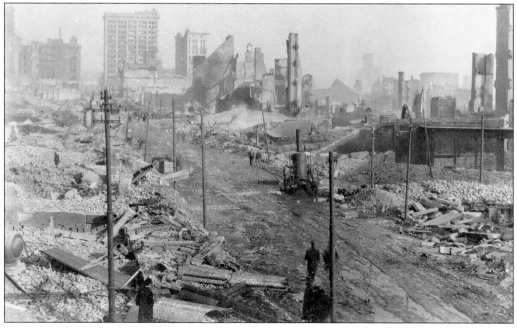

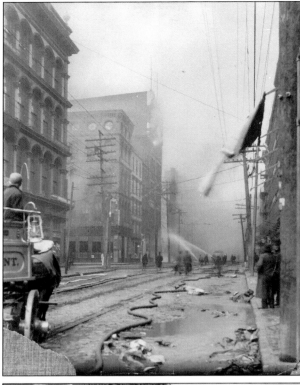

Two remarkable aspects of the Baltimore fire include the lack of fatalities and the rebuilding. Since the fire started on a Sunday, most residents were at church and not in the vicinity of the fire; therefore, the only injuries sustained were to the firefighters battling the blaze. The Great Chicago Fire of 1871 should have served as a warning to major cities to prepare for the outbreak of large fires, but Baltimore did not heed the warning. Once the fire was extinguished, however, they city chose to completely redevelop. Power lines were placed underground, and an enclosed sewer system was constructed. The entire downtown section was revamped. Streets were widened to accommodate fire trucks, and docks were widened for dredge boats to aid in extinguishing future fires. Buildings that were newly constructed were equipped with modern fire prevention.

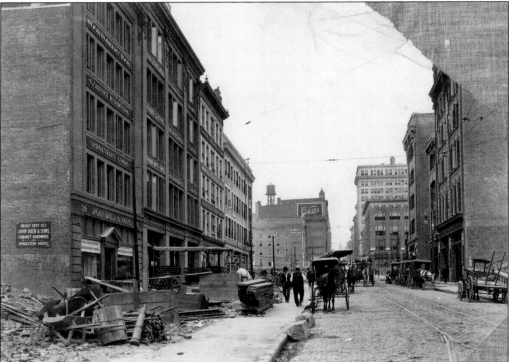

In 1904, August Fenker opened his Weiss beer brewery. Having come from a family of brewers, with his father at Bayview and his uncle at National, Fenker was prepared to serve a small segment of the German population in Baltimore, producing just 500 barrels per year. By 1911, he included the production of birch beer. In 1919, the plant was closed and turned into a garage that was operated by his son. The looming specter of Prohibition, which was bandied about the United States for years, began to threaten the existence of the aforementioned breweries. Some, like Fenker, changed the products manufactured. Brehm's Brewery eventually shifted to ice manufacture, which was lucrative. Some breweries switched over to meatpacking and other industrial endeavors in hopes of surviving the impending economic downfall. (Right, DNB; below, BMI.)

August Fenker.

VALUE OF MANUFACTURES AND CLASSIFICATION OF INDUSTRIES
BALTIMORE METROPOLITAN DISTRICT—YEAR 1913

REFERENCE No.	INDUSTRY — CHARACTER OF	Number of Establishments Engaged In	SKILLED Male	SKILLED Female	UNSKILLED Male	UNSKILLED Female	EXECUTIVE SALES AND CLERICAL Male	EXECUTIVE SALES AND CLERICAL Female	TOTAL	VALUE OF MANUFACTURES	PER CENT. OF TOTAL MANUFACTURES	LOCAL SALES	SHIPMENTS	REMARKS
1	BREWING AND DISTILLING:													
	Malt Liquors	12	669	-----	91	-----	145	28	933	$5,820,841	1.65%	$5,529,799	$ 291,042	See Page
	Spirituous Liquors	14	141	-----	188	-----	105	7	441	2,951,867	.83%	837,532	2,114,335	See Page
2	CEMENT, CLAY AND PRODUCTS:													
	Builders' Materials	19	185	-----	187	-----	33	3	408	452,831	.13%	323,819	129,012	See Page
	Brick	9	487	-----	881	-----	37	2	1,407	1,252,134	.35%	935,655	316,479	See Page
	Crockery and Pottery	3	12	55	-----	-----	3	-----	70	204,000	.06%	134,000	70,000	See Page
	Paving and Roofing Materials	7	123	-----	606	-----	64	3	796	4,062,766	1.15%	3,994,080	68,686	See Page
3	CHEMICALS, OILS, ACIDS, ETC.:													
	Acids, Fertilizer, etc.	23	749	3	1,008	-----	446	51	2,257	15,976,306	4.52%	2,229,783	13,746,523	See Page
	Paints, Varnishes and Dyes	11	98	1	87	-----	90	24	300	1,933,084	.55%	323,550	1,609,534	See Page
	Soaps and Perfumery	11	21	26	33	25	31	14	150	441,519	.12%	190,211	251,308	See Page
	Miscellaneous Chemicals and Oil	15	370	-----	678	7	346	41	1,442	11,965,946	3.39%	2,253,500	9,712,446	See Page
4	DRUGS AND PREPARATIONS	65	354	440	200	154	389	165	1,702	6,673,355	1.89%	987,346	5,686,009	See Page
5	FOOD PRODUCTS:													
	Bakery Products and Flour	381	860	62	666	269	487	98	2,442	6,740,474	1.91%	4,221,528	2,518,946	See Page
	Cereals and Spices	5	36	25	57	16	33	5	172	2,068,581	.59%	417,699	1,650,882	See Page
	Preserved and Canned Foods	52	876	515	1,935	2,914	578	75	6,693	12,971,721	3.67%	1,028,317	11,943,404	See Page
	Slaughtering and Meat Packing	49	826	-----	359	-----	158	9	1,352	18,533,317	5.25%	8,451,605	10,081,712	See Page
	Candy and Confectionery	50	429	831	266	709	153	60	2,448	5,680,978	1.60%	1,317,578	4,363,400	See Page
	Miscellaneous	12	41	28	73	87	82	50	361	2,199,167	.62%	374,755	1,824,412	See Page
6	FOUNDRY AND MACHINE SHOP PRODUCTS:													
	Bridge and Structural Iron	11	408	10	206	-----	50	8	682	1,344,388	.38%	548,780	795,608	See Page
	Electrical Equipment	7	134	-----	11	-----	45	4	194	478,870	.14%	259,225	179,645	See Page
	Machinery	51	2,871	2	946	20	323	28	4,190	6,730,245	1.90%	1,664,261	5,065,984	See Page
	Railway Cars and Construction	6	3,641	-----	1,105	-----	463	2	5,211	11,422,110	3.23%	1,990,000	9,432,110	See Page
	Miscellaneous	39	2,571	68	3,430	-----	416	35	6,520	11,833,751	3.35%	1,209,343	10,624,403	See Page
7	GLASS AND PRODUCTS:													
	Bottles and Glassware	5	398	1	785	59	68	11	1,322	1,681,521	.48%	490,915	1,190,606	See Page
	Mirrors and Stained Glass	6	69	-----	13	-----	8	1	91	158,494	.04%	92,912	65,582	See Page
8	JEWELRY AND SILVERWARE:													
	Jewelry	14	61	11	24	-----	17	3	116	322,100	.09%	187,780	134,320	See Page
	Silverware	10	279	-----	43	-----	57	10	389	974,000	.28%	458,500	515,500	See Page
	Miscellaneous	8	30	5	4	-----	4	2	45	64,000	.02%	31,500	32,500	See Page

Many tried to ride the strong wave of resistance in Baltimore by arguing the economic damages that would ensue from Prohibition due to the loss of employment. This included millions of dollars in revenue for breweries and industries affiliated with the brewing industry, like farming, coopers, bread makers, maltsters, bottle cap manufacturers, carpenters, seal manufacturers, glassware dealers, pipe manufacturers, printers, sign manufacturers, hardware dealers, ice dealers, and cork dealers, among others. Additionally, it is most relevant to include the revenues lost on the local and federal levels from tax collection. The Anti-Prohibition League sent out annual manuals detailing the devastation that would be wrought from enacting dry legislation. They calculated the total loss to the US Treasury and state, local, and municipal treasuries combined at $328,527,868 annually if the legislation passed. The estimate was based upon IRS revenues, customs revenues, and US Commerce Department figures. (BMI.)

Four

THE DRY YEARS OF PROHIBITION AND ITS AFTERMATH

Baltimore was the center of resistance to Prohibition in Maryland. Despite efforts to the contrary, National Prohibition was passed and ratified on January 16, 1919. Twenty-nine states had independently voted for and enacted dry legislation prior to National Prohibition taking effect in 1920. Since the 19th century, both the Women's Temperance Movement and the Anti-Saloon League pushed to make America dry. (Author.)

Senator John Phillip Hill led the Wet party in Maryland against the 18th Amendment. He had staunch supporters like H.L. Mencken (house shown below), *Baltimore Sun* writer and outspoken critic of Prohibition. Once the 18th Amendment took effect, there was no provision for enforcement written into the law. The Volstead Act was written to enforce the 18th Amendment and took effect shortly thereafter. Many like Mencken quickly realized the damage caused by Prohibition in the form of a severe economic downturn and a substantial rise in crime, particularly organized crime. Prohibition did not succeed in Baltimore, because there were far too many who opposed it and refused to follow the legislation. Some breweries, like Baltimore Brewing Company, tried to produce near beer (0.5-percent alcohol-content beer) but were closed by dry agents for actually producing real beer. (Left, LOC; below, author.)

The Crusaders was an organization started by Fred Clark in Cleveland in 1932 to repeal the 18th Amendment. It quickly became a national organization with an office in Baltimore for the wet population to fight Prohibition. National airtime was purchased, and the voice of the Crusader took to the air in an effort towards repeal. After repeal, the Crusaders continued until 1937 as a political organization. (LOC.)

As organizations fought for repeal, another trend returned in Baltimore and around the country—the homebrew. It was possible to fill a prescription for beer, whiskey, or wine from one's doctor, but few could afford that. Instead, many, like Mencken, turned to brewing their own beer. This trend caught on in Baltimore for some, but others created unhealthy concoctions based on shoe polish or cologne.

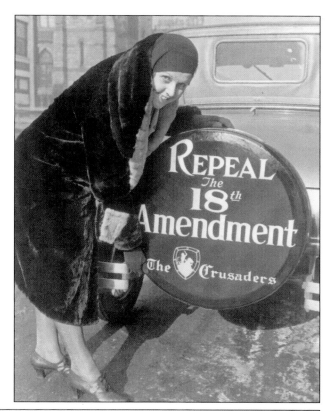

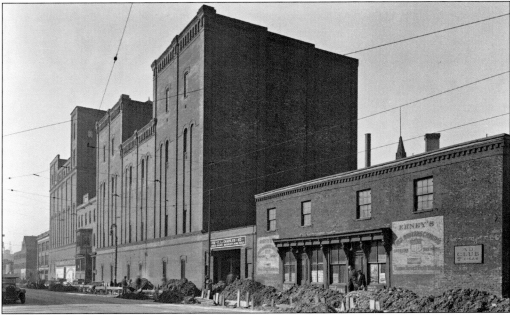

The American Malt Company was named American after the former brewery of Fred Bauernschmidt, which it purchased and occupied with the onset of Prohibition. The American Malt Company produced its own malt to make hop-flavored malt syrup for breakfast dishes and those who missed the taste of hops. It also sold home-brewing supplies. In 1931, Henry Wiessner sold the John F. Wiessner Brewery to the American Malt Company when the need for expansion was realized. The Wiessner Brewery sat vacant after closing with the arrival of Prohibition. King Gambrinus was taken down and moved to the garden, a sad reminder that the god of beer no longer reigned in Baltimore or America.

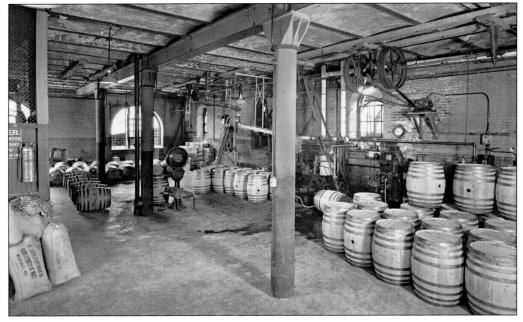

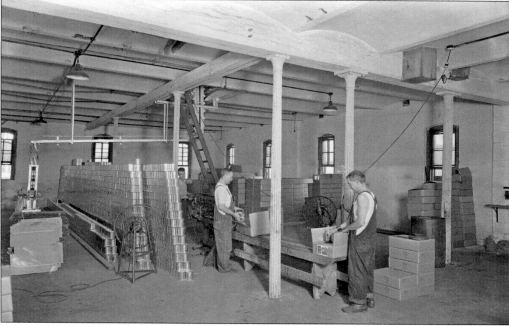

Life was better for those who found employment at industries like American Malt while so many struggled during the Great Depression. Boxing canned syrup was a good job with consistent pay. Substantial improvements were just around the corner for the workers at American Malt in 1933, as the country began to lean towards repeal; the promise of reopening the brewery appeared imminent. Prior to repeal, the American Malt Company decided to begin reequipping the plant for the production of beer. The support for repeal was overwhelming, considering the contrary and detrimental effects wrought by the 18th Amendment and the Volstead Act. It was a gamble the Fitzsimmons family, owners of American Malt, felt secure investing in.

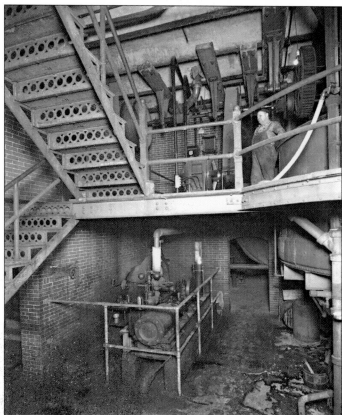

DERWOOD & UNDERWOOD

Finally, Prohibition came to an end with the passage by Congress of the 21st Amendment on February 20, 1933. This was the first time in history that an amendment was created to repeal a previous amendment. Congress did not leave the decision in the hands of the state legislatures to ratify this amendment, however; conventions of states were required to vote on ratification instead. On December 5, 1933, the necessary number of states (36) ratified the 21st Amendment. At 7:00 p.m. on the evening of December 5, 1933, Pres. Franklin Delano Roosevelt signed the proclamation ending Prohibition. This was anticipated months in advance due to the aforementioned decline in revenues and increase in crime. If the Wet party's statistics were to be trusted, increased divorce rates, illiteracy, and poverty can all be attributed to the failed experiment that was Prohibition. (LOC.)

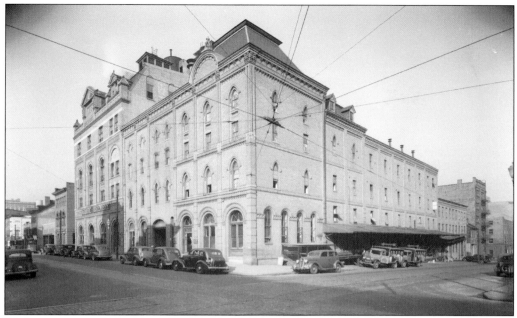

Within minutes of 3.2-percent beer becoming legal in Maryland on April 7, 1933, Globe Brewery delivered Arrow (real) Beer to the Rennert Hotel on Saratoga Street. Among notables that were the first to drink real beer after repeal was H.L. Mencken. Arrow Beer was eventually delivered to several locations throughout the city, and the taps once again flowed. This first real beer in Baltimore was brewed by John Fitzgerald, assistant brewmaster. Fitzgerald was brewmaster with Thomas Beck, Thomas Dukeheart, and National prior to Prohibition. Fitzgerald worked for Globe producing near beer during Prohibition. It was one of the few breweries in Baltimore to succeed in this endeavor. The brewery sponsored a contest to develop a slogan for near beer. The winning slogan, "Arrow Beer, It Hits the Spot" was kept and used for the real beer produced after repeal. (Above, BGE; below, AHTA.)

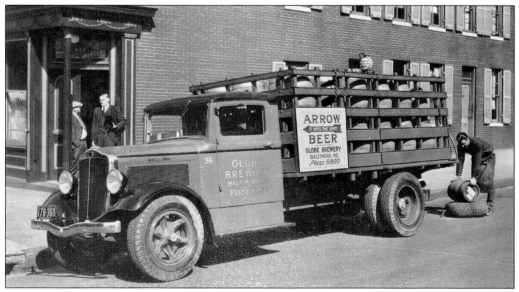

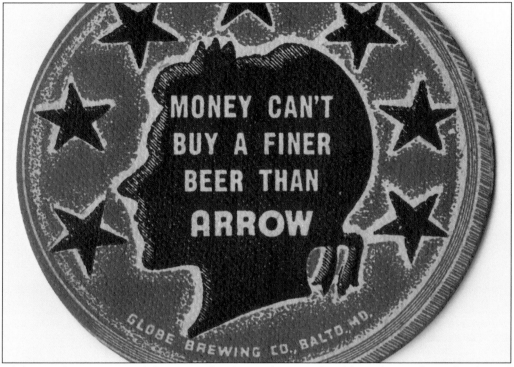

Globe was better prepared than most for the production of real beer due to the technological advancements made prior to Prohibition. Globe was the first brewery to move away from steam power to purchased power in 1912. Purchased power was offered by the Consolidated Gas Electric Light and Power Company as a way to increase electrical capacity by purchasing from a central station (Spring Garden) instead of producing it at the brewery with steam turbines. The brewery still needed to undergo renovations to meet increased demand. Globe immediately began a $350,000 rebuilding program to double capacity to 225,000 barrels per year. Some of the renovations included glass-lined storage tanks, an air-conditioned fermenting cellar with humidity control, a new filtration system, and 35 new beer trucks. Globe prepared for the requirements of the modern consumer in both production and marketing. (Above, BMI; below, EP.)

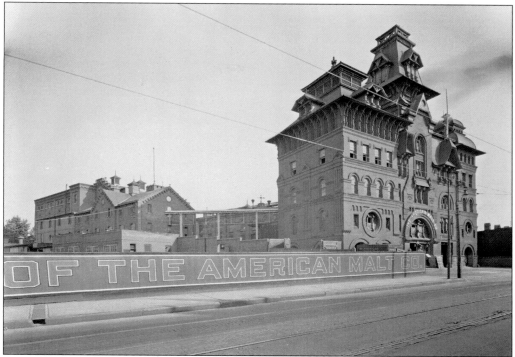

After the repeal, the American Malting Company ceased to exist. Instead, the company filed paperwork in March 1933 to change its business name to the American Brewing Company. It still produced its own malt and supplied malt to a vast number of breweries along the east coast. By July 1933, American Pilsner was being delivered throughout Baltimore to thirsty customers. American was the third brewery in Baltimore to produce real beer. Despite the late start, the plant was still able to produce over 100,000 barrels that first year. American Pilsner was quickly in demand, and the Fitzsimmons family realized the need to upgrade and expand operations. (Above, BGE; below, AHTA.)

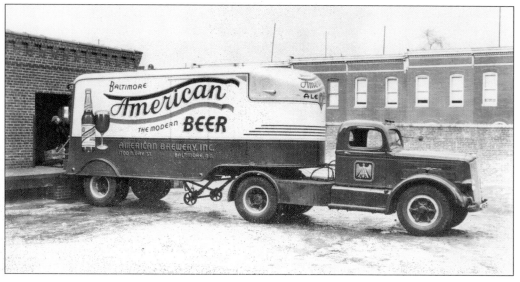

Beginning in 1934, the American Brewery would embark upon a series of improvements totaling $600,000 by 1949. The first improvements made were the addition of a boiler room and a new entertainment building. The most notable upgrade would be the switch from steam to purchased power in April 1936. This switch allowed for modern technological equipment that improved the quality and efficiency of the beer production and increased capacity. The first machine running off of purchased power was a cooling unit that produced a more consistent product during the fermenting process. A row of storage tanks in the American Brewery cellar and the gravity-fed grain elevator are shown at left. This was a vast improvement upon the 19th-century gravity elevators, which were powered by steam instead of electricity, as steam-powered grain elevators were always a high fire hazard. (Both, author.)

The grain chute seen at right was the beginning of the brewing process. Since American Brewing Company produced its own malt, costs were kept down and the process was expedient. Every corner of the American Brewery was used, whether for storage, malt production, fermenting, brewing, cooling, bottling, or marketing. Not unlike today, breweries advertised to the public in magazines and newspaper, as well as via the streets. Below, one aspect of the American Brewery marketing plan can readily be seen on the side of this corner row house. This was a typical advertisement for breweries in Baltimore during the 1930s. (Right, author; below, EP.)

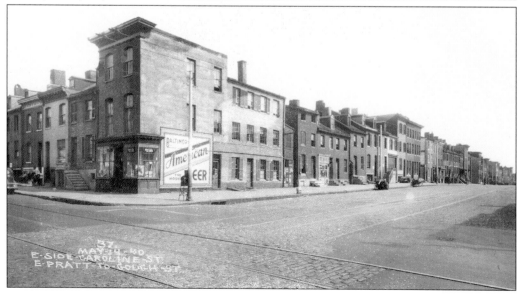

George Gunther Jr. Brewing Company, established by father and son after selling the latter's plant to the beer trust, attempted to survive Prohibition by producing near beer and manufacturing ice. Near beer was a failure, but ice manufacturing seemed to carry the business through until 1931. The plant was in receivership, and the family's business was sold to Abraham Krieger, who chose to keep the name Gunther. Gunther saw new life with repeal. Counting on the name recognition and demand, Gunther's was the second real beer produced in Baltimore on April 7, 1933. The beer was marketed as if it were the original Gunther Beer, established in 1880. That was just fine for thirsty Baltimoreans, harkening back to the decades before Prohibition, when Gunther Beer flowed from the beer taps of Baltimore like liquid gold. (Both, BMI.)

Kreiger quickly realized that although Gunther's was once again producing beer, it still needed to improve the plant and expand the facilities to accommodate the demand. In June 1934, Gunther switched over from steam to purchased power to provide for this growth. Expansion was rapidly undertaken along with the modernization of all brewing equipment. The bottling department was also rebuilt at this time. A five-story addition accompanied the new storage buildings that were constructed the following year. Gunther Brewing was expanding to accommodate the demand for its product locally and growing demand in the southern United States. This would not be the end of the growth for Gunther, as the coming decades would require even more from the brewery. (Both, BMI.)

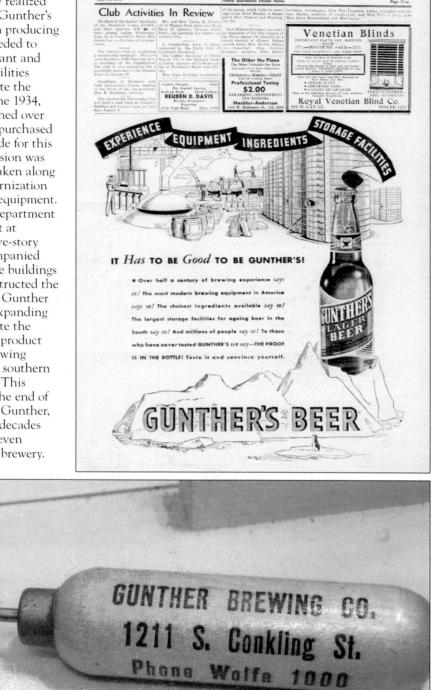

National Brewing Company was also resurrected after the repeal of Prohibition. Samuel Hoffberger purchased the vacant plant and installed Carl Kreitler as vice president and brewmaster. Since all equipment had been sold off during Prohibition, there was a substantial amount of money, equipment, and time needed to begin operations. Similar to the decision made by Gunther, Hoffberger kept the name National because it resonated with locals. Like Gunther, National went just as far in claiming heritage to the original brewery of 1885 in its advertising. Fairly quickly, a new brew house, bottling plant, refrigeration plant, and warehouse were added, as well as a the gravity-fed grain elevator, all of which purchased power helped efficiently run. Glass-lined storage tanks were also installed, and the capacity of the brewery reached 250,000 barrels per year by the time it opened in January 1934. (Left, MHT; below, BGE.)

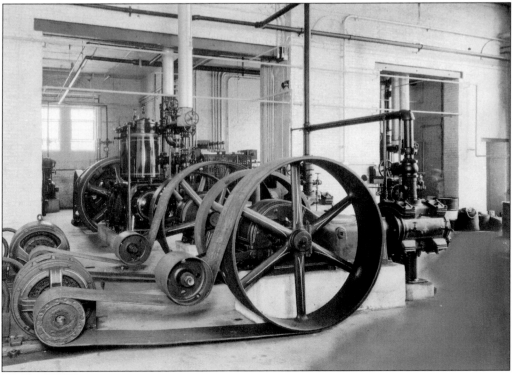

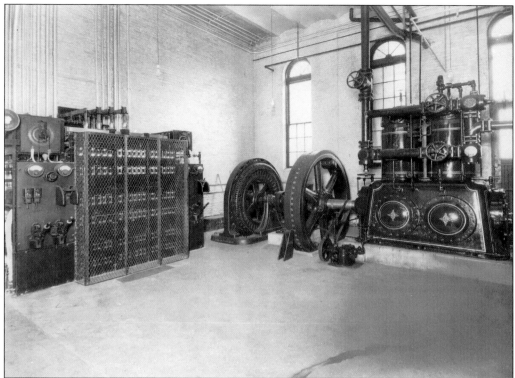

The first beer produced was National Bohemian in 1934. This was not the same recipe as the National Bohemian of the 19th century. People didn't seem to mind, and business boomed. National added a pilsner that same year, National Premium. The appeal was strong, and capacity was increased, which was facilitated by purchased power. By the 1940s, National was nationally recognized and selling beer across the country, as seen in the advertisement at right. National Beer was so delicious it could be served with Christmas dinner. To meet the increased consumer demand, National produced around 500,000 barrels per year. (Above, BGE; right, BMI.)

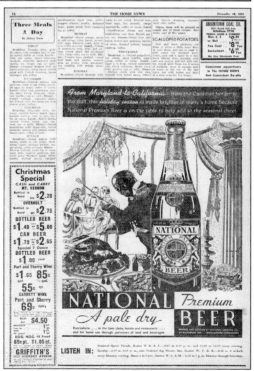

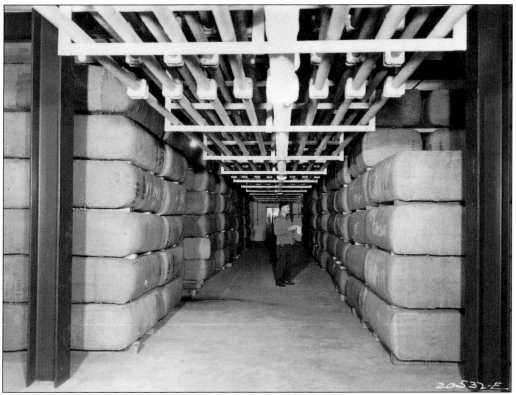

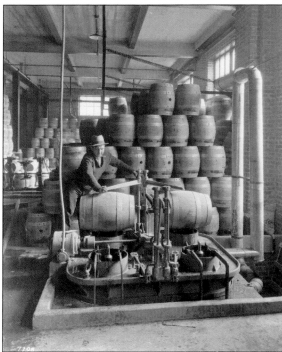

National embraced the post-Prohibition crowd, and although it initially traded on the old National Brewery's name and fame, the brew was now appreciated on its own merits. One of the major differences between the old National Brewery and the refurbished new National Brewery was that most of the work was done by hand in the 19th and early 20th centuries in the plant. In the 1940s, with the aid of purchased power and new technologies, most of the work was done by machine. Make no mistake, however, there were still a few things that needed a human touch. Above, inventory is being taken in malt storage. Below is the interior of the cooperage while the kegs that house the fine beer are being produced.

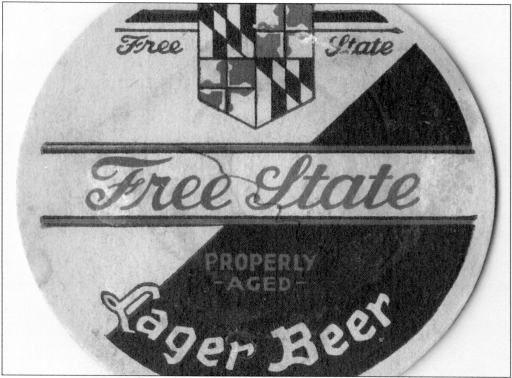

Free State Brewery was another post-Prohibition Baltimore brewery. It was the original Frederick Bauernschmidt Brewery, which was purchased and eventually sold by the American Malt Company. The brewery was purchased in April 1933 by a group of stockholders that included a Bauernschmidt family member. The brewery was immediately converted to purchased power, and the entire brewery was remodeled and reequipped with the most modern brewing equipment available. The total cost to remodel the plant was $1 million. The brewery began producing beer by September 1933 with an annual capacity of 350,000 barrels per year. This was the largest brewery operating at the time in Baltimore. (Above, author; below, EP.)

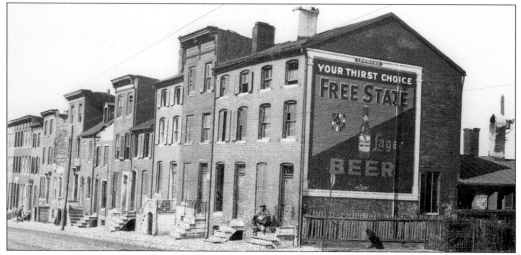

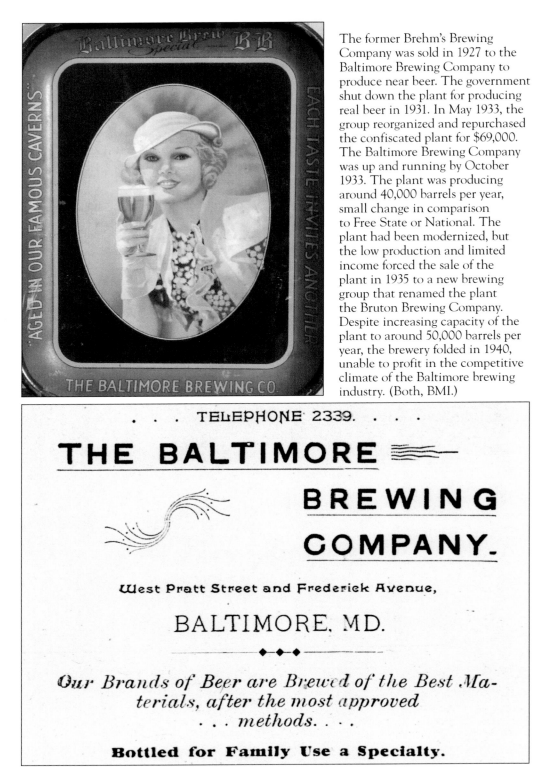

The former Brehm's Brewing Company was sold in 1927 to the Baltimore Brewing Company to produce near beer. The government shut down the plant for producing real beer in 1931. In May 1933, the group reorganized and repurchased the confiscated plant for $69,000. The Baltimore Brewing Company was up and running by October 1933. The plant was producing around 40,000 barrels per year, small change in comparison to Free State or National. The plant had been modernized, but the low production and limited income forced the sale of the plant in 1935 to a new brewing group that renamed the plant the Bruton Brewing Company. Despite increasing capacity of the plant to around 50,000 barrels per year, the brewery folded in 1940, unable to profit in the competitive climate of the Baltimore brewing industry. (Both, BMI.)

. . . TELEPHONE 2339. . . .

THE BALTIMORE

BREWING

COMPANY.

West Pratt Street and Frederick Avenue,

BALTIMORE, MD.

◆ ◆ ◆

Our Brands of Beer are Brewed of the Best Ma-
terials, after the most approved
. . . methods. . . .

Bottled for Family Use a Specialty.

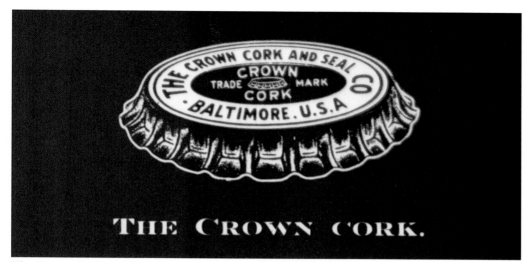

THE CROWN CORK.

The Crown Cork and Seal Company continued to flourish through Prohibition by bottling sodas and other liquids instead of beer. With the repeal of Prohibition, it began to thrive, and the cork bottle cap remained true and trusted by Baltimore breweries. Crown Cork and Seal needed to upgrade its facility in the 1940s to keep up with the demand for bottle caps and crowning machines. It chose to abandon the old private power plant and contract for purchased power with an annual load of 3380 horsepower. This large load was necessary, since it operated 24 hours per day to meet demand. Comparatively, all of the Baltimore breweries using purchased power had a combined total load of only 3845 horsepower annually at this time. (Above, CCS; below, MHT.)

The American Can Company was a Baltimore icon. It had been canning foodstuffs and goods since the 19th century, when canning was in its infancy. Prior to the 18th Amendment, it attempted to can beer. This was unsuccessful, as it could not keep the fizz in the can, nor could it eliminate the metal taste absorbed by the beer. After repeal, technology improved, and by 1935, American Can had perfected the beer can with a lining that prevented any metallic taste and a method of retaining the fizz in the beer. American Can had successfully canned the first beer; the problem was convincing a brewery to market canned beer. Krueger Brewing Company of New Jersey was willing to try. The canned beer was sold in Richmond, Virginia, and met with incredible success. This quickly caught on in Baltimore and the nation.

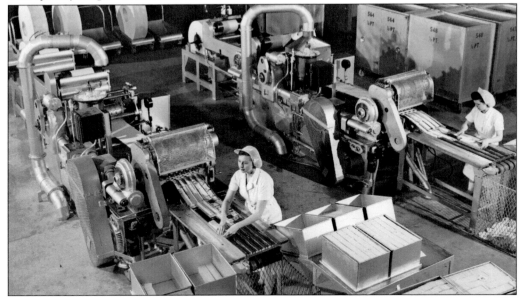

Five

Baltimore Breweries and the Changing Tastes of America

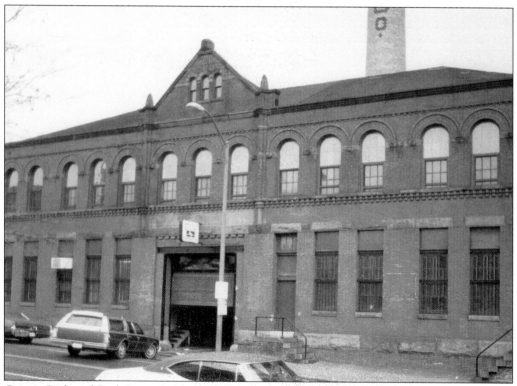

Crown Cork and Seal Company survived the dawn of the beer can it was forced to compete with in the 1940s. Beer sold in cans became quite popular when the United States began to ship beer overseas to the soldiers and sailors fighting the war. Despite these setbacks, Crown continued to thrive and expand, which was necessary to supply the changing tastes of America. (MHT.)

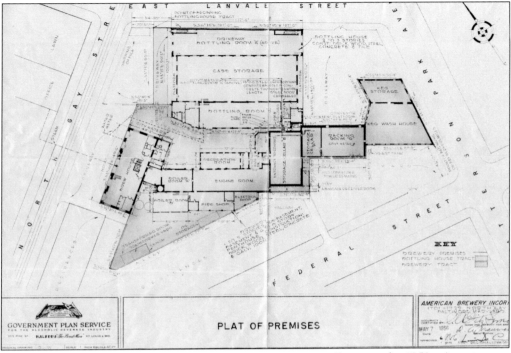

PLAT OF PREMISES

AMERICAN BREWERY INCOR

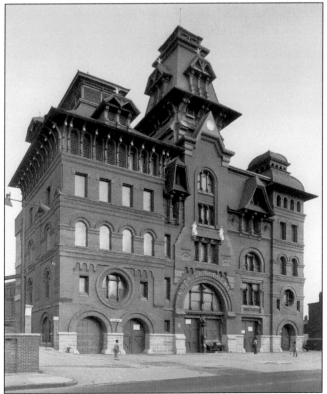

Entering the 1950s, American Brewery was still producing great beer. The high volume of production, however, still could not meet demand, and the brewery was once again in need of expansion. The plat above from 1956 shows the extent of the planned renovations for the American Brewery. The improvements not only increased capacity, but once again, the quality of the brews had improved as well. The brewery was operating at around 300,000 barrels per year post-renovation. This was necessary to keep pace with the larger breweries in the city, as well as the national breweries out of the Midwest. (Above, BMI; left, HAER.)

These extensive renovations included an assembly line for packaging beer. American was bottling its own beer in recyclable bottles of varying size, as well as bottling beer in throwaway bottles, kegs, and other containers, all in addition to canning its beer. This need for a multifaceted assembly line to package its product was at the heart of the 1956 renovations. One of the innovations embraced by American was the use of liquefying carbon dioxide. This was crucial for two reasons; first, it was added to beer in a gaseous form, causing the fizz, and second, it helped to purify the beer. American was at the forefront of beer technology in Baltimore. (Right, BMI; below, BGE.)

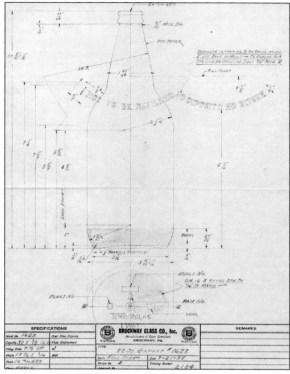

The brewing and oversight of production at American fell to the brewmaster and eventual vice president Raymond Klussman (above) upon the death of Fitzsimmons. In combination with the extensive renovations in 1956, the product was outstanding, winning a gold medal in 1956 from the Brewer's Association of America. This was the highest honor ever bestowed upon a Baltimore brewery up to that time. Klussman oversaw every aspect of the brewing process from its inception to the temperature the grains were cooked at and for how long (below). The tight control and demand for excellence contributed to American's success, as a gold medal allowed American brewery to compete on the national stage.

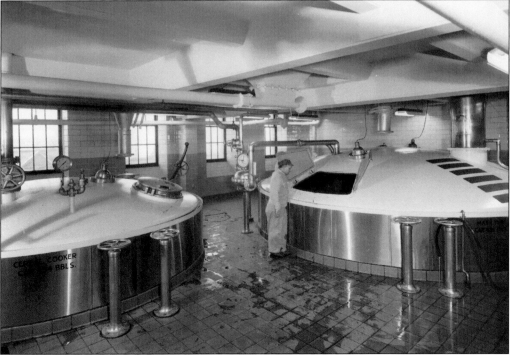

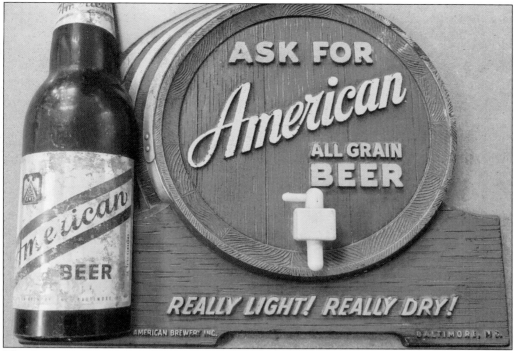

The American Brewery in the late 1950s is clearly a picture of success. The improvements made to the brewery physically and organizationally permitted the plant to thrive at a time when tastes were changing. Many Americans leaned toward the mass-produced beers that were lighter and weaker than the craft brews Baltimore had a history of producing. Economically speaking, the mass-produced beers were cheaper and ubiquitous. Another reason for the shift can be directly linked to the war. During World War II, American beers were canned and shipped overseas to the sailors and soldiers. Even the groundbreaking can designed by American Can Company could not stop the quality of beer from diminishing by the time it reached Europe and the Pacific. Once the military returned home, some had acquired a taste for this weakened beer. (Above, Jeff Smith; below, author.)

The Arrow Beer sign at the end of the street became one of the few remnants of a once-prolific brewery. The Globe Brewery continued to produce its trademark Arrow Beers, expanding the plant again in 1947 to meet demand. Globe took on Hal's Beer as a subsidiary in 1952 and added yet another beer in 1962. Unfortunately, it was not enough, and Globe was forced to shut down operations due to its inability to keep up with the mass-produced beers from breweries such as Anheuser-Busch and Pabst. In 1963, Globe ceased brewery production and outsourced all brewing operations to Cumberland Brewing in western Maryland. By 1965, Globe was sold, and the brewery was demolished for the construction of a parking lot. This was a sad end, most certainly not befitting the storied brewery. It was also a portent of things to come for many Baltimore breweries.

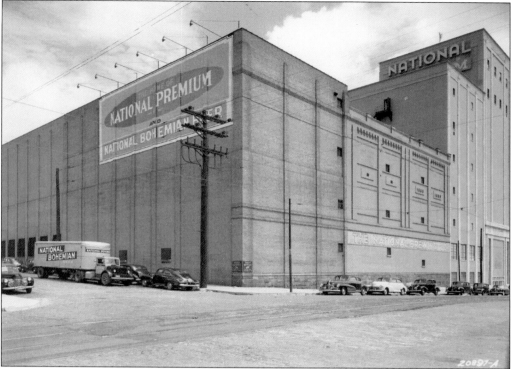

One brewery that had little trouble keeping pace with the larger national breweries was National Brewing Company. National was a thriving brewery, even during the war, embracing canned beer and shipping National Bohemian overseas for the military. National was the first to produce a six-pack of canned beer. This delivery method was quite popular, and many breweries followed suit. Under the Hoffbergers, National continued to expand, building yet further additions from 1952 to 1954. This was also a critical year, as National ranked among the top 20 breweries in the country. The standards were exacting, and the beer was constantly tested for quality. This required National to open additional plants in Detroit, Michigan, and Orlando, Florida, in 1955 to accommodate national demand.

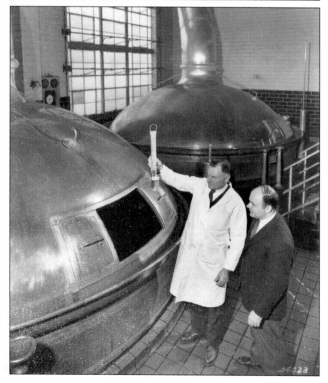

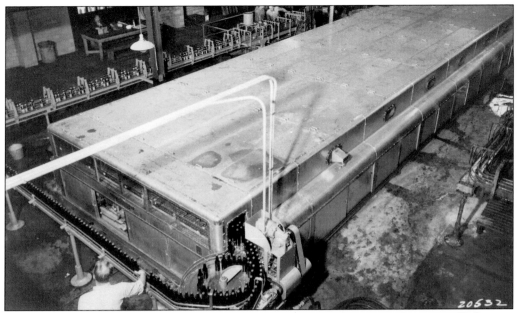

In 1960, one of the most significant additions to the National Brewing Company (Baltimore branch) came in the form of a high-speed bottling plant, a bottle washer, and a palletizer system for the automatic stacking of bottle palettes for safe transport. The old bottling line from the 1940s can be seen above, while the modern line can be seen below. This new system allowed for the sanitary bottling and processing of National Bohemian and National Premium beers with quality control measures built in for faster production. By 1964, production topped 1 million barrels per year. This level of production from the Baltimore plant alone allowed National to keep pace with the major national breweries. Total renovations to the National brewery topped $2 million after Prohibition was lifted.

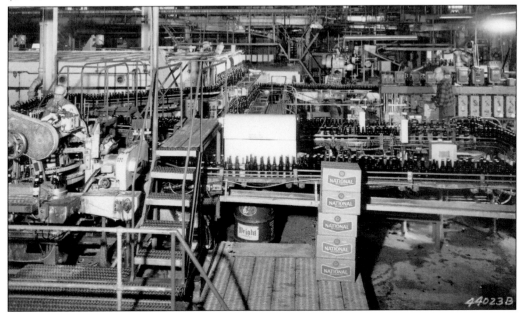

By the 1960s, National Brewing Company was also sponsoring the Baltimore Colts. National's motto, "from the Chesapeake Bay . . . the land of pleasant living," had become the insignia that demonstrated to locals and the country as a whole that Natty Boh was a Baltimore product and always would be. Sponsoring the Colts was just another reminder of how entrenched National was in Baltimore, despite the national appeal. The brewery always kept close ties with Baltimore, and Jerold Hoffberger would eventually come to own the Baltimore Orioles along with the National Brewing Company. The brewery, with Hoffberger's support, sponsored small local and minor-league teams as well, exhibiting an investment in the community that helped make National Beer a success. (Right, author; below, BMI.)

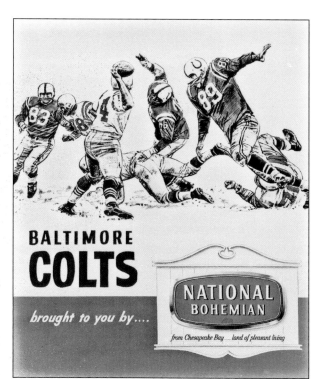

Gunther Brewery also pushed into the mid-20th century with as much force as it could muster. Large-scale renovations were undertaken from 1955 to 1956, as seen in the Taylor and Ketcham architectural plans above. A complete renovation of the brewery was necessary based on the national recognition Gunther lager received. The brewery decided upon a steel-frame construction that

embraced a brick facade with ceramic, granite, stone, copper, and cast iron accents. The new office building was equipped with private baths adjacent to many offices and several windows to capture light. Based on the number of women's rooms and their accommodations in comparison to the men's facilities, one assumes a fair amount of the 600 employees at Gunther were female. (MSA.)

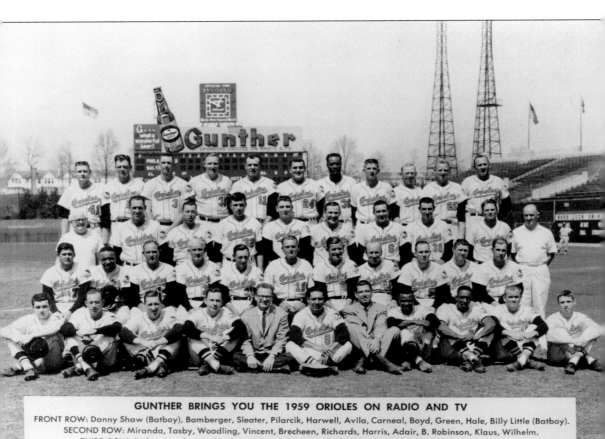

GUNTHER BRINGS YOU THE 1959 ORIOLES ON RADIO AND TV

FRONT ROW: Danny Shaw (Batboy), Bamberger, Sleater, Pilarcik, Harwell, Avila, Carneal, Boyd, Green, Hale, Billy Little (Batboy).
SECOND ROW: Miranda, Tasby, Woodling, Vincent, Brecheen, Richards, Harris, Adair, B. Robinson, Klaus, Wilhelm.
THIRD ROW: Diskin, Harshman, Ginsberg, Pappas, Fisher, Nieman, Carrasquel, Walker, Gardner, Weidner.
BACK ROW: O'Dell, Brown, Hansen, Zuverink, Triandos, Portocarrero, C. Johnson, Stock, Finigan, Lockman, E. Johnson.

The renovations were completed in 1956, and output was more than 800,000 barrels per year. The new bottling department was capable of processing 1,650 cans and bottles combined per minute. Gunther was a competitive brewery on both the local and national levels. Renovations are stated to have totaled approximately $7 million. To augment its success, the brewery also sponsored the Baltimore Orioles. By this time, the Orioles were part of the American League of Major League Baseball. The 1959 Orioles met with almost as much success as the 1894 Orioles of the National League under Harry Vonderhorst. The most renowned member of the team was, of course, local hero Brooks Robinson, third from the right in the second row. In 1959, the prolific third baseman played in 88 games and had 89 hits including 4 home runs, 24 RBIs, and 29 runs. This was just the beginning of his storied career with the Orioles, and Gunther supported the efforts. (EP.)

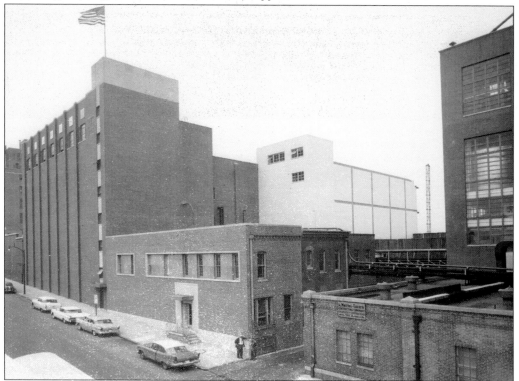

In December 1959, shortly after the exhaustive renovations, Gunther Brewery was sold to Theodore Hamm Brewing Company for approximately $20 million. This Minnesota-based national brewery decided to remodel the Gunther Brewery to increase production. Above is the architect's sketch of the planned structure. These modifications would exceed $10 million. This renovation included new glass-lined Pfaudler ageing and fermenting tanks and a new laboratory, new stock house, yeast plant, and grain storage, all to meet Hamm brewing quality benchmarks and increase capacity. Many of the planned renovations were complete by late 1961, but Hamm's Brewery in Baltimore had a long way to go to win local community support.

A planned marketing strategy of the Minnesota brewery was to win over the locals by supporting the local team. In Baltimore, the company continued the sponsorship of the Baltimore Orioles, as Gunther had done the year before. Unfortunately, that is where the local support ended. The rather poor decision made by Hamm's in 1960 was to discontinue the Gunther brand, a local and national favorite. In addition, Hamm's designed a Midwestern marketing approach that included lyrics and scenery depicting Minnesota culture and heritage that was considered unappealing and insulting to the locals, who just wanted their Gunther beer. The special Hamm's yeast was advertised as a taste feature of Hamm's since 1898. That still did not sway the Baltimore natives, who demanded the familiar and preferable taste of Gunther. After realizing the miscalculations and the loyalty of Baltimore beer drinkers to their preferred beer, Hamm's attempted to bring back Gunther in 1962. It was not a success, as many did not believe it was the true Gunther's recipe but Hamm's in old Gunther packaging.

One year later, in 1963, an announcement was made that Theodore Hamm Brewing Company was selling the Baltimore plant to the Brooklyn-based Schaefer Brewing Company. Schaefer, having just sold a Midwestern brewing plant of its own, did not make the same mistakes as Hamm's. Schaefer purchased the ailing brewery, as well as the name Gunther, but did not sell Hamm's beer. Honoring the local tradition, advertising was more in line with the region and the loyalty of the beer consumers in Baltimore. In addition to sponsoring local minor-league teams like the Baltimore Clippers hockey team, Schaefer spent $1 million to modernize the plant once again, including a shrink-o-matic machine for palletized beer. Schaefer fared much better than Hamm's, reaching into markets like Puerto Rico and developing region-specific products for varying tastes in New York and Puerto Rico. (Both, MHT.)

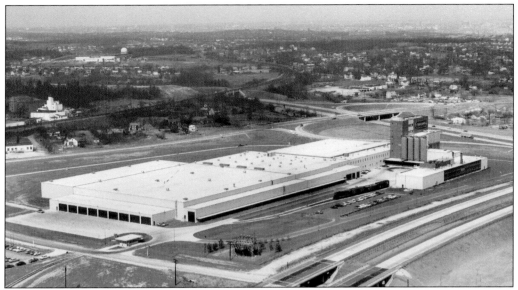

The reach of the larger Midwestern breweries into Baltimore did not stop with Hamm's Brewing Company. In 1961, Ohio-based Carling Breweries opened its seventh regional plant in Baltimore, Maryland. All of the most modern brewery equipment was installed into the multimillion-dollar facility, including copper brew kettles, 1,000-barrel-capacity glass-lined tanks, vast temperature-controlled fermenting tanks, and a host of other up-to-date equipment. Carling completed the massive Halethorpe facility with an annual production capacity near 1 million barrels per year. It was an impressive operation in total. Carling's massive facility created greater competition in the beer industry in Baltimore, which was already struggling against the larger national breweries like Schlitz, Pabst, and Anheuser-Busch.

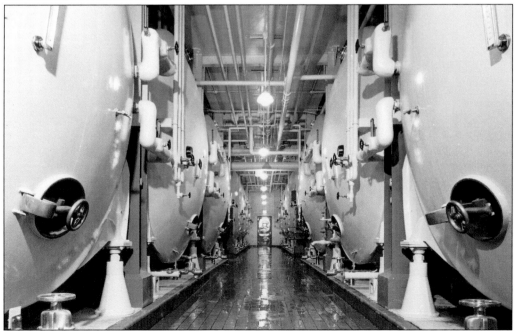

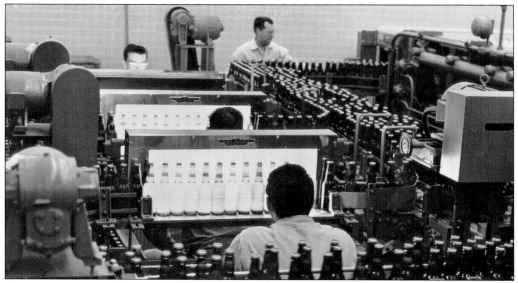

Above is the state-of-the-art bottling and packaging plant in the Carling Baltimore facility. As seen in the photographs, Carling was famous for its Black Label beer. The logo, "Hey Mabel, Black Label," was a catchy and easily recognizable slogan developed by Carling marketing in the late 1950s. By the time the new Carling plant was operational in Baltimore, Mabel was still called for Black Label, but only for a short while. Mabel was abandoned as a Carling slogan in 1965. The decline in sales reflected the public opinion towards the new advertising campaign of Carling. Mabel was eventually brought back, but profits had declined substantially.

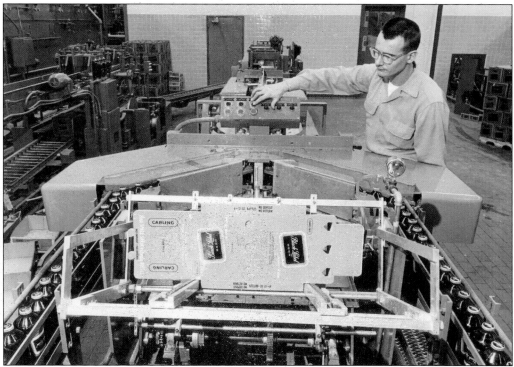

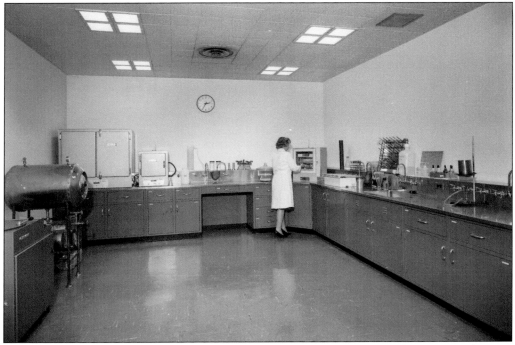

The laboratory above was another critical component of the new Carling facility in Baltimore. It was central to the brewing of consistent beer that consumers would support by returning for more Black Label and other Carling offerings such as Stag and Heidelberg. In addition to the consistency of the products, Carling also gained name recognition and support via sponsorship. Carling was a longtime sponsor of Indy Racing, and in 1972, it sponsored the car driven by rookie Larry Smith in the NASCAR Winston Cup Series. This proved a wise decision, as Smith was rookie of the year in 1972, but this was not enough for Carling to keep up with the cost of running multimillion-dollar plants across America, particularly when cost-cutting measures were being taken by other mass producers like Pabst.

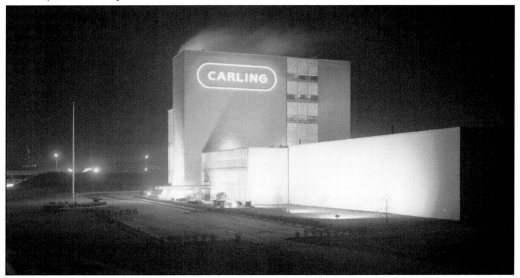

The difficulty Carling had was the mass production of beer at lower cost to offset the exorbitant overhead required to operate the large plants. National Brewing Company was direct competition for Carling in the same region, as well as nationally with their National Colt 45, Bohemian, and Premium brands. A decision was made in 1975 that the breweries should merge for efficiency and profitability. Sixteen million dollars was paid to National, and the National Plant on Conkling and Dillon Streets was abandoned in favor of the multimillion-dollar facility in Halethorpe. For a while, National was still brewed on the shores of the Chesapeake Bay and considered a Baltimore native, but not for long. Even the merger could not save Carling National. (Right, BGE; below, BMI.)

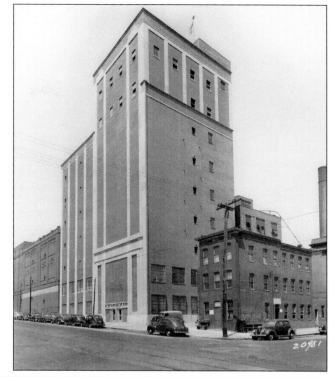

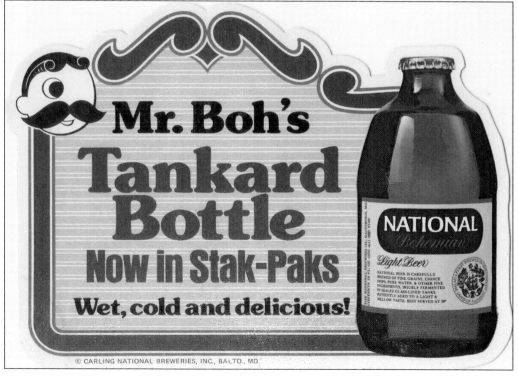

© CARLING NATIONAL BREWERIES, INC., BALTO., MD.

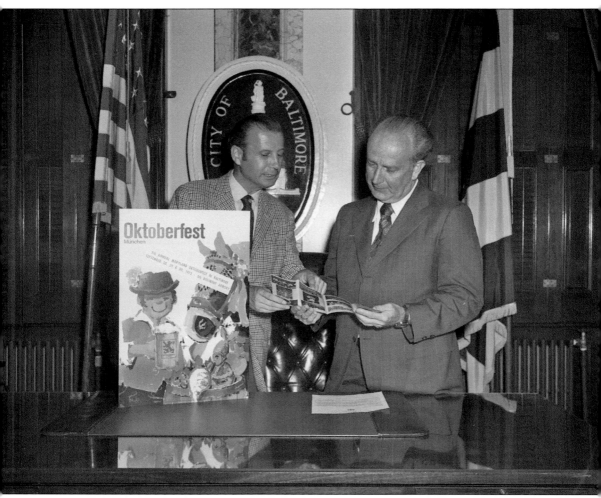

Despite the difficulty with profitability and mass-market competition, Baltimore still embraced its heritage. In the above 1973 photograph, Mayor William Donald Schaefer receives promotional materials for Baltimore's Fifth Annual Oktoberfest. Baltimoreans understood the German brewing heritage and celebrated this. Mayor Schaefer, a Baltimore icon who would become governor, was a steadfast supporter of what made Baltimore unique. This included the Colts, the Orioles, and the once-rich brewery-filled city, among many other fine traditions. Although Schaefer himself was not much of a drinker, he understood the economic realities of Baltimore-based breweries and their link to the city's vibrant past. As a four-term mayor from 1971 to 1987, his public support was evident, although his tactics were a bit unorthodox. Schaefer helped to revitalize a city in decline. Unfortunately, one local industry that was not revived in the 1970s and early 1980s was brewing.

Baltimore was known for its rich brewing history, Fort McHenry, resistance to Prohibition, sports teams, riots of the 1960s, and iconic political figures. However, one tradition that all Baltimoreans honored was its bounty from the Chesapeake Bay: blue crab. Tradition had them served with Old Bay seasoning, formed into Maryland style crab cakes, or baked Chesapeake-style over chicken, but no matter how one ate them, there would always be a great brew at hand to wash them down. A slight twist on the traditional German beer garden, Bud's Beer Garden in Highlandtown always had plenty of local Baltimore beer and steamed crab. Bud Paolino's was a Baltimore institution for more than three decades. The popularity of the steamed crabs at Bud's required the building of an additional hall just to meet the large crowds always present for crabs and local brew.

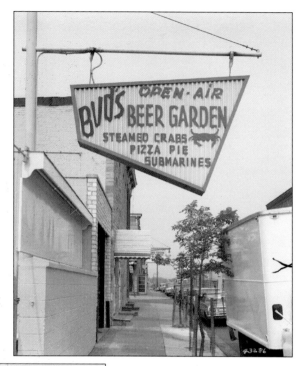

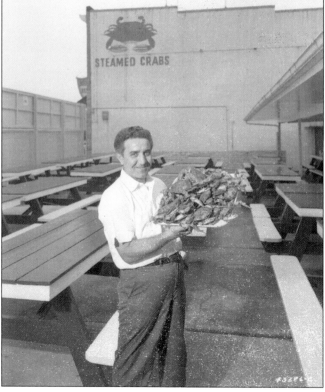

Baltimore was a city in a constant state of evolution. As quickly as breweries grew and expanded, competition from nationally produced breweries forced closures. By the late 1970s, the brewing industry in Baltimore was barely recognizable from just a few decades prior. American Brewery had closed, National merged with Carling and was then sold to G. Heileman Brewing Company, and Gunther changed hands twice to fall under Schaefer. During the late 1970s, Baltimore suffered the same problem plaguing the brewing industry throughout the nation: 95 percent of the nation's beer market was taken by the large national brewers such as Anheuser-Busch and Pabst. This left only 5 percent of the market share to the regional breweries. To compete, breweries needed to turn out at least 1 million barrels per year, a large percentage of which was for export. The cost of packaging and shipping alone was prohibitive to regional breweries. Although locals were loyal, the major labels were cheaper and easier to come by. A new frontier was about to be forged, however, as change was brewing in Baltimore.

Six

THE RETURN OF CRAFT BREWS TO BALTIMORE

By the late 1970s, the major national brands had absorbed local Baltimore breweries or forced them out of business. American Brewing Company brewed its last beer in 1973. National merged with Carling and was sold to Heileman. Gunther was absorbed by Schaefer. Stroh's, a national chain with a strong German heritage, absorbed Schaefer, Schlitz, and eventually, G. Heileman. The future did not look promising for brewing in Baltimore. (BMI.)

A few determined individuals decided to change the brewing industry in Baltimore and the nation beginning in 1978. Pres. Jimmy Carter singed HR 1337 into law, legalizing the brewing of beer in one's own home for the first time since Prohibition. Additionally, in the mid-1980s, a savvy businessman named Hugh Sisson, owner of Sisson's Restaurant, worked with devoted politician Sen. George Della of Maryland to change Maryland's outdated Prohibition-era laws that made brewpubs illegal in the state. Once legislation was passed legalizing brewpubs to operate again, the floodgates opened. In October 1989, Sisson's became Maryland's first legal brewpub since Prohibition was enacted in 1920. A handful of other brewpubs opened shortly thereafter, providing Baltimoreans with the opportunity to experience local craft brews once again. It was the foundation of a new brewing industry in Baltimore. (Both, BMI.)

RECEIVED SEP 2 8 1989

You Are Cordially Invited To Attend
A Reception & Brewery Tour
At Sisson's South Baltimore Brewing Co.

The First Pub Brewery
In The State Of Maryland

Saturday
October 7, 1989
Two to Four PM
36 East Cross Street
Federal Hill, Baltimore

Regrets Only 539-2093
Parking Available On West Street Parking Lot

36 E. Cross Street Baltimore, Maryland 21230 (301) 539-2093

BALTIMORE'S BEST CAJUN/CREOLE RESTAURANT -
Baltimore Magazine Reader's Poll 1986, 1987, & 1988

Location: 36 E. Cross St - Federal Hill
Six Blocks South of the Inner Harbor
Walking Distance From The Hotel District

Credit Cards: Visa & Mastercard - We Do Not Accept American Express

Reservations: Accepted For Seating By 7 PM ONLY - call 539-2093

Groups: Parties of Up To 24 Can Be Accomodated - Please Call Ahead
Two Rooms Available - One Casual, One White Table Cloth
Total Seats: Currently 72 in Three Rooms, Soon to be 110 in Five

Dress: Casual Parking: Street, Not Usually Difficult in the Evening

HOURS
LUNCH	Mon thru Fri	Noon to 3 PM
DINNER	Nightly	5 to 11 PM

Our Story

Time was when every region had its own local brewery - something which meant more to the area than just the beer. It was part of the local culture, part of the daily fabric of living, part of the local identity. Unfortunately, what with Prohibition and the emergence of the large national breweries, local breweries vanished – and their traditions with them.

A New Tradition Begins!

In an era when mega-brewers dominate the landscape, Clipper City Brewing Company represents the renaissance of the *local* brewery.

Clipper City was founded by Hugh Sisson, a 6th generation native of Baltimore, Maryland. As a college student in the 1970s, Hugh didn't like the bland, yellow, fizzy stuff that defined American beers of the time. But during a semester in England, he tasted beers of wonderful flavor. The seeds were sown for a career in good beer.

After graduate school, Hugh returned to Baltimore in 1980 to run Sisson's, his family's pub, and re-modeled it to reflect the English establishments he had enjoyed. Sisson's quickly became renowned as a 'beer destination point'. In fact, in 1989, Sisson's became the first brew pub in Maryland.

With the American craft beer movement in full swing, Hugh decided to focus exclusively on beer. Clipper City Brewing Company began production in December of 1995.

The Clipper Ship

The brewery is named for the renowned Clipper ship of early American history. First built in the port of Baltimore, the Clipper ship is a symbol for much that is remarkable about the Chesapeake region. It captures the hardy nature of a working class heritage, the romance of a bygone era, a strong nautical heritage, and a commitment to craftsmanship of the highest caliber.

Our Mission

Clipper City Brewing Company approaches each day as a new opportunity to be a good will ambassador for the Chesapeake region and for the wonderful art of brewing. We spread the word about the amazing breadth and diversity of beer styles. We demonstrate that good beer can contribute to a quality lifestyle. We champion enthusiasm for fresh, distinctive beers.

Come join us in this adventure. We welcome you aboard!

Our Goals

- To develop a portfolio of beers and brands diverse enough for every beer consumer.
- To develop a network of sales and educational support second to none.
- To be a positive partner in the lifestyle of every community in which we do business – from product quality to responsible business practices.
- To have fun in the process

www.clippercitybeer.com

CLIPPER CITY BRANDS

"The Superior Craft"

Our original product line features classic styles that focus on the Chesapeake Bay region. Available year round, the Clipper City brands are the perfect "local suds"... anywhere!

McHenry
Approx. 5% ABV
Old Baltimore
Style Lager Beer
– patterned after a famous Baltimore beer from the 1940s – brewed with 100% malt and German noble hops. Pale in color, well structured and refreshing, FABULOUS with steamed crabs! Also pairs well with shrimp.
Bronze medal GABF 2007.

Clipper City Gold Ale
Approx. 4.5% ABV
American style golden ale – deep gold color with floral and spicy hop aroma. Brewed with pale, Munich, and caramel malts and Cascade, Centennial and Hersbrucker hops. Well rounded, fruity, and complex. Pairs well with salads, mild cheeses, pulled pork BBQ. **Bronze medal GABF 2000.**

Clipper City Pale Ale
Approx. 4.75% ABV
Classic copper colored English style pale ale – pale & crystal malts with Fuggles, Goldings, and Cascade hops. Firm malt character with earthy hop notes. Pairs well with cheddar, curry dishes, pizza.

MärzHon
Approx. 5.25% ABV
Traditional Märzen (martz—en) lager
– amber color with a rich, toasty malt flavor and slightly sweet finish. Because it is made in Baltimore, we call it MarzHon (martz-HON), since in Baltimore, everyone is referred to as Hon! Pairs well with grilled sausages, crab cakes, and pit beef "samiches."
Gold medal GABF 2007.
Silver medal GABF 2006.

With the great success of South Baltimore Brewing Company (the brewing part of Sisson's), Hugh Sisson decided to branch out into the realm of brewing without the pub. Strict Maryland laws prohibited brewpubs from opening a separate facility for the distribution and sales of large quantities of beer outside of the pubs, limiting business profits and availability to consumers. Selling his shares in the family business, Sisson opened Clipper City Brewing Company in December 1995. This was his passion. Clipper City paid homage to both the earliest German craft-brewing traditions in Baltimore and the ships that marked Baltimore's place in history. At Sisson's, Hugh was brewing approximately 1,000 barrels per year. The facility purchased in Halethorpe, combined with the new, large-capacity equipment, markedly increased brewing capacity as planned but also increased the difficulty. There was a learning curve working on such a large scale in regards to both engineering and quality control. Additionally, the immediate and voluminous number of orders was staggering for a brand-new plant that was still finding its sea legs. (Author.)

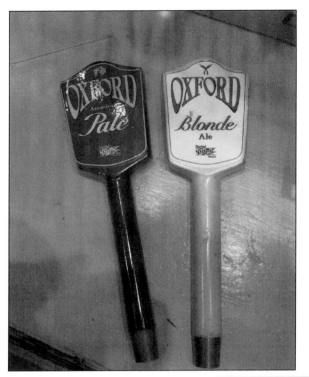

At about the same time Sisson's was opening the brewpub, two gentlemen from Britain were opening a microbrewery, the first in Maryland since Prohibition. Oxford Brewing Company, originally called the British Brewing Company, opened in 1988. The tradition was, of course, English. The ales were acclaimed, but the brewery struggled. A change in ownership coupled with expansion and the introduction of a raspberry wheat ale could not save the struggling microbrewery due to a flat beer market. Clipper City, having worked through the initial kinks of the new brewery, had begun what is known as contract brewing. This is the brewing and bottling of beers for other labels to create volume and stay afloat. Clipper City acquired the Oxford label in 1998, after its last beer was brewed that December. (Both, BMI.)

While Oxford Brewing was closing its doors in 1998, another Baltimore brewery opened. Stephen Demczuk, PhD, was a molecular biologist researching in Germany when he fell in love with beer. He began the first beer of the month club in Europe. By 1997, he created The Raven Special Lager and served it to the US Embassy staff in Germany at their annual gathering. On the heels of his German success, Demczuk and partner Wolfgang Stark decided to open an American branch of the brewery to bring this true German lager to the United States, and Baltimore was his chosen location. As a native and a huge Edgar Allen Poe fan, Baltimore was truly the only place that made sense. The name of the company, Baltimore-Washington Beer Works, was easily recognizable for those in Europe as well. Since 1998, Demczuk has seen his share of difficulties, from packaging to marketing, but the Black Forest, Germany, branch kept the corporation profitable until success carried the Baltimore facility. Now, several awards later, two new beers are in production along with a brewpub. (Author.)

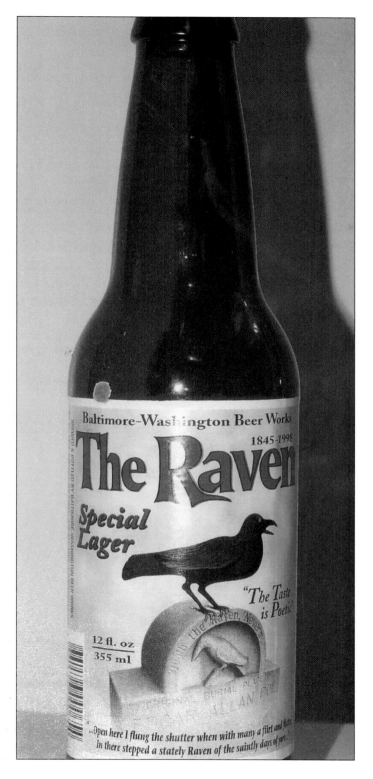

In 1993, an English-style brewery was opened in Baltimore called Oliver's. The brewery was created to supply the brew for the Wharf Rat, a downtown restaurant across from the convention center. All equipment was imported from England to brew the ales traditionally with open fermentation, and to boot, a British brewmaster was hired. This met with great success, and eventually, a second pub was opened in Fell's Point. The brews were award-winning, despite change in ownership and the renaming of the pub to the Pratt Street Ale House. Sadly, the ales are not easily accessible outside of the restaurants, but they are available to take home in growlers. (Both, author.)

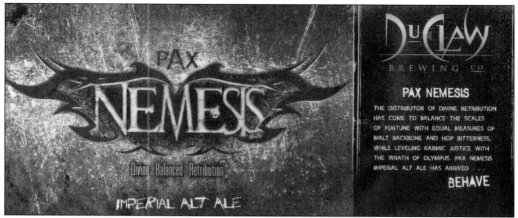

One of the breweries that Clipper City was contract brewing for in 1996 was DuClaw, a Bel Air brewpub. Eventually, it opened its own brewery and another pub in Fell's Point in 2004. This harkened back to the early years when locals would stop in to the nearby brewpub to cool off with a tasty beer. Although the Baltimore pub closed in 2009, two DuClaw pubs are still open in Maryland. (Author.)

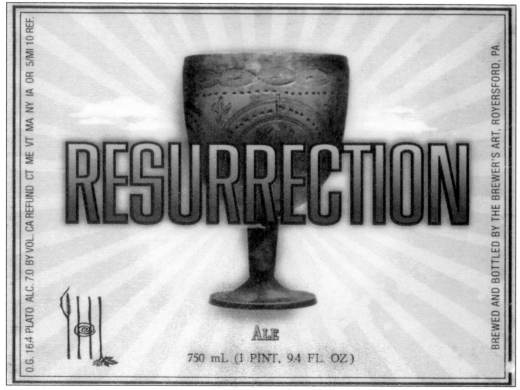

In 1996, another brewpub took advantage of Maryland's changed laws, and Brewer's Art, Old Line Brewers, LLC, opened in the Mount Vernon district. In every respect, this brewpub has embraced Baltimore's rich history, from the historical location on Charles Street to the Old Line moniker of the brewing company to the award-winning craft brews they produce. Although brewed in Pennsylvania, the beers are still a Baltimore product. (Author.)

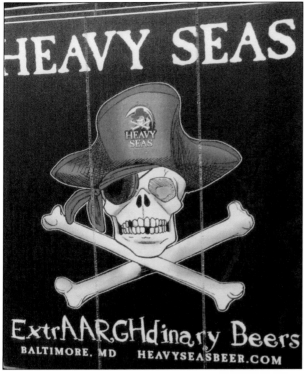

As Clipper City was building its reputation and quality, the brewery launched a new line of beers called Heavy Seas. It was a continuation of the Baltimore maritime tradition coupled with the quality brewing taught by treacherous navigation of a new business, a difficult economy, and the harnessing of perfect ingredients for exceptionally balanced brewing. This was an immediate success for Clipper City, and its expanded line of beers in 2003. The quality and consistency allowed the brewery to thrive while others were collapsing. DeGroens Brewpub on Albemarle Street in Baltimore was the second brewpub in the state after Sisson's (and Prohibition). The true German-style brewpub with several awards closed in 2005, citing profitability issues. The building was said to be worth more than the brewery. It was torn down in 2008 for the construction of a Fairfield Inn. (Both, author.)

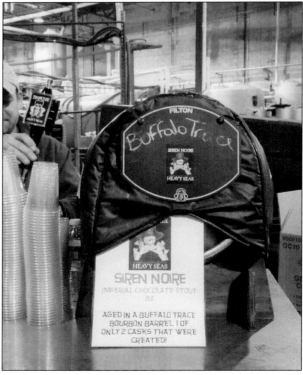

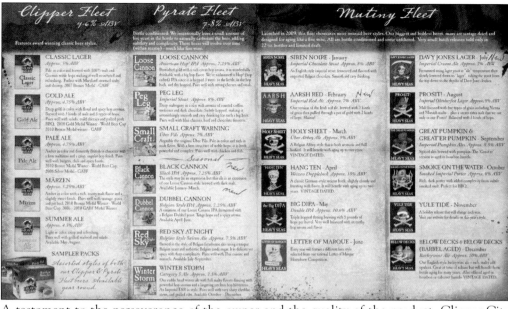

A testament to the perseverance of the owner and the quality of the product, Clipper City was finally thriving. The decision was made to name the entire lines of beers Heavy Seas and incorporate or disband the Clipper City line completely in 2010. A seasonal line was created to accent the standard fleets. The reputation and quality of Heavy Seas Beers won over demanding local connoisseurs. A Heavy Seas phenomenon developed, with an almost cult following of Heavy Seas drinkers appearing at festivals and release parties, sometimes dressed as pirates. Each brew is carefully named by the charismatic founder, generally finding its roots in Baltimore and the city's strong brewing and maritime traditions. To honor this tradition, the brewery has given back by participating in oyster recovery efforts with the Chesapeake Bay and other community outreach programs. (Both, author.)

Another addition to the Baltimore brewing industry is Stillwater Artisanal Ales, founded by Brian Strumke in 2009. Brian started as a home brewer in Baltimore and drew his inspiration from his travels, brewing collaborations, and diverse ingredients. A self-proclaimed gypsy brewer, he is truly an artist who searches the world to collaborate with other artists to present one of the finest craft beers in Baltimore. In 2011, he was proclaimed second on the RateBeer's list of Top New Brewers in the World. The artistry extends beyond the ingredients to the incredible and imaginative label creations, as seen here. A generous spirit, he shares his experiences in crafting beer with home and plant brewers the world over, searching for new ingredients and new brewing ventures. (Both, author.)

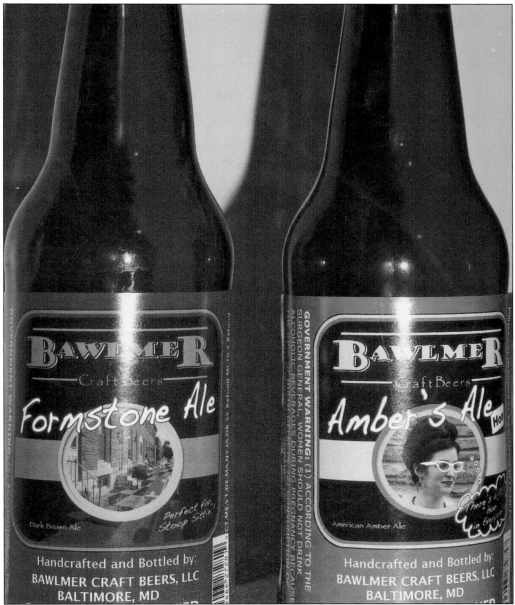

The most recent addition to the Baltimore brewing scene is John O'Melia and his Bawlmer Craft Beers, opened in 2010. O'Melia, a Baltimore native, travelled extensively and developed an appreciation for quality craft beers from around the world. An environmental engineer by training and a home brewer by hobby, he always wanted to open a brewery. After 15 years, he finally got around to it. Bawlmer operates out of the old Crown Cork and Seal Plant on Eastern Avenue in Baltimore. His label is a fun take on what makes Baltimore unique: from the ubiquitous use of "hon" in Baltimore, which was written on the Baltimore-Washington Parkway overpass for years, to the local pronunciation of Bawlmer. This is a truly local label that lets everyone know where it's brewed. O'Melia's goal is to make beers that are accessible to one and all, from everyday drinkers to beer connoisseurs. (Author.)

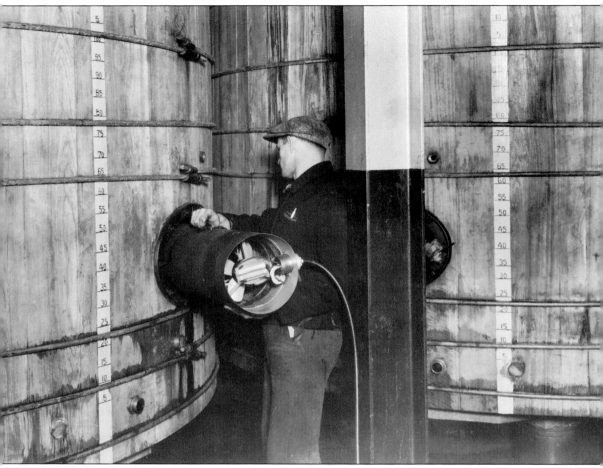

What is so unique about Bawlmer is the brewing method. O'Melia uses the traditional English brewing process. This includes using gas-fired brew kettles instead of the electric kettles that the majority of plants use today. This method causes a caramelizing reaction that infuses the caramel flavor into the beer, making it darker in color and richer in taste. Additionally, O'Melia uses the top-cropping open fermentation process. This is a traditional technique, seen above in 1949 at National Brewing Company. Open fermentation produces more non-fermentable sugars, making for a heavier brew. Most beers fermented in this style range between six and seven percent alcohol by volume. Oliver's is the only other Maryland brewery that uses open fermentation. The temperature of the mash and the ratio of water to grain are critical in this process to produce a quality product. Bawlmer currently markets two ales: Amber's Ale and Formstone Ale. A new addition to the line is expected in 2011 in the Belgian-style ale called Crabby Abbey.

Despite closing in 1973, the American Brewery was not forgotten. This architectural wonder steeped in Baltimore's illustrious brewing tradition stood as a fading icon of grandeur that once was a thriving Baltimore industry. The entire neighborhood surrounding the brewery deteriorated into what many passersby would call a war zone. Hulls of burned-out row houses, gangs, prostitutes, and drug dealers were abundant in the area. For many years, efforts were underway in Baltimore to save and revitalize this historic monument and the neighborhood. No solution was forthcoming until one nonprofit organization spotted the building in 2005 and decided it would undertake the monumental task. Funding was finally arranged for the nonprofit organization known as Humanim to regenerate and eventually occupy the structure. Humanim provides job training and assistance to those who might otherwise have difficulty finding employment. (Both, author.)

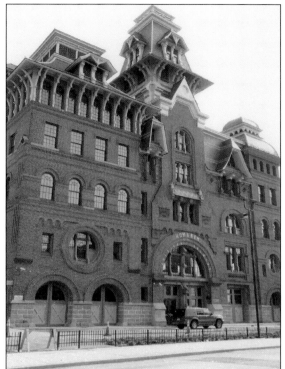

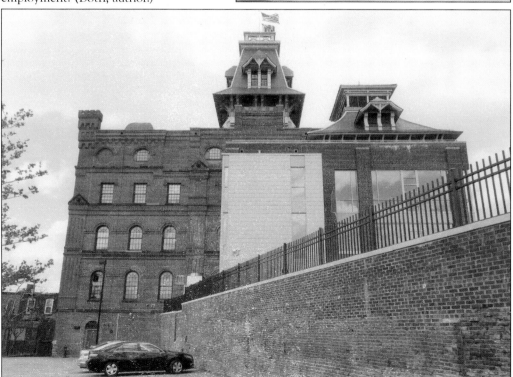

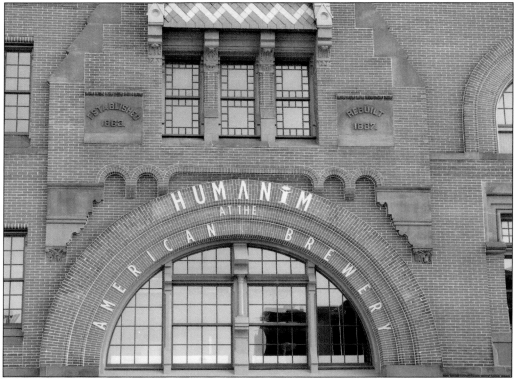

Humanim was a perfect fit in this struggling area. Humanim also honored and embraced the history of the building and the neighborhood it would come to occupy. It intentionally preserved as much of the structure as possible in the $25-million renovation. As seen above, the exterior demonstrates minimal modifications, including the Humanim name in addition to the American Brewery logo. Upon entering the lobby, the original staircase of the brewery still stands, although it leads nowhere, and the gravity-fed grain elevator has been preserved throughout the structure, even though it is not a requirement of the historical designation. Old beer kegs were used as waste receptacles, and breweriana was placed as decor on each floor. Graffiti from 1933 was left on the ceiling as homage to the repeal of Prohibition and the beginnings of the brewery as American. (Both, author.)

Once the building was structurally sound, Humanim incorporated as much of the industrial equipment from the brewery as possible back into the renovated and open space. It preserved the boiler in what is now the boardroom and turned it into a fireplace, and the rings from the fermenting tanks still imprint the floors. One of the old kettle hulls remains slightly altered and has become a partially enclosed quiet area for employees. Great pains were taken by Humanim and the architect firm of Cho Ben Holback and Associates to stick as closely to the original design and colors of the building as possible. The windows were completely restored to their original splendor, and floors were added where once only catwalks existed so the windows could be used. The paint was even mixed to match the original colors of the brewery. (Both, author.)

The window at left is the interior portion of where the American Brewery logo resides. To the left of the window, the grain elevators can be seen behind the reflecting Plexiglas. The colored glass used in the interior rooms of the building was replicated from broken pieces of the original central stained glass windows. This center window looks out onto the slowly rejuvenating neighborhood. The original grain chute was kept as part of the decor and now acts as centerpiece to many meetings. Every consideration was made to repurpose as much as possible in an effort to retain the integrity of the building inside and out. (Author.)

Above, the bottling department stands adjacent to the rejuvenated structure, but no renovations have yet been undertaken. The use of the additional structure has not yet been determined, but the structure would need to undergo intensive foundational rebuilding, as a rear wall is collapsing. Additionally, the vast network of underground tunnels that served as storage and cooling cellars remains accessible and under consideration for development in the future. The former home and offices of John F. Wiessner, founder of the original brewery, were already renovated and serve the senior members of the community. Since the renovation of the American Brewery was completed in 2009, the neighborhood has undergone vast change. New business continues to come to the area, members of the community have learned essential skills to hold jobs—some at Humanim—and the community has been infused with hope. (Both, author.)

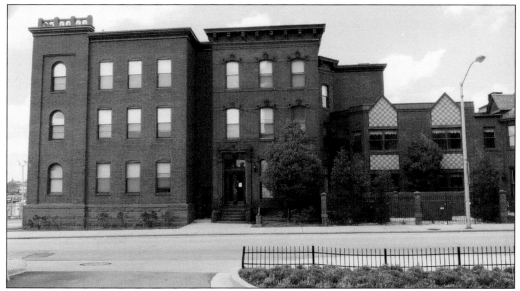

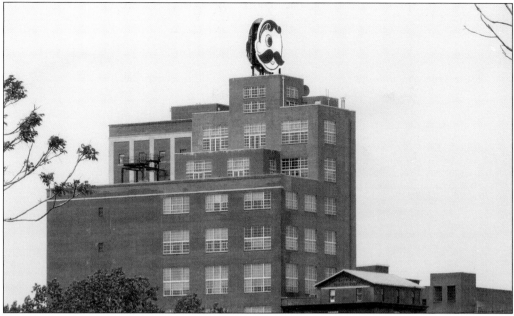

In 1996, Stroh's purchased G. Heileman Brewing Company, owner of National Beer since 1978, and shut down the multimillion-dollar brewing facility. National Beer was no longer brewed in the "land of pleasant living" for the first time in its storied history. In addition to brewing National Beer in Pennsylvania, Stroh's stopped producing kegs of Bohemian brew in favor of cans and bottles alone. This was a stunning shock to many in Baltimore and Maryland, as that meant Natty Boh would no longer be available in draught. For those who had grown up with Natty Boh as the local beer of choice, it added insult to injury. (Both, author.)

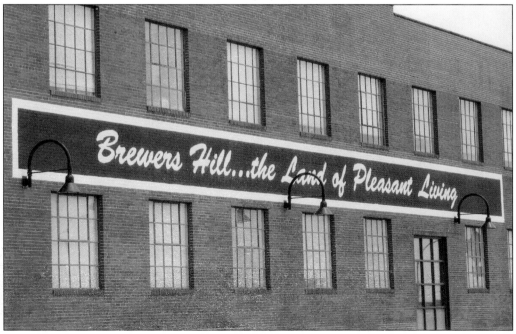

With the news of the closing, all hope was not lost for the brewing tradition in Baltimore, as home brewer Marc Tewey opened his Brimstone Brewery in the abandoned National Brewery plant in 1996. After having his beer contract brewed for a few years to gain entry to the market, Brewer's Hill (the affectionate name for the old National and Gunther plants) seemed a perfect opportunity to open his own brewery. Tewey's plant ran at a capacity of 3,000 barrels per year and included his own bottling line. Tewey bartered with locals to get the brewery operational and garnered much support for the renewal of Brewer's Hill. He met with enough success that he was approached in 1998 by the larger Frederick Brewing Company and sold his brewery, leaving the National plant vacant of brewing once again. (Both, author.)

All was not lost for Brewer's Hill and the National Brewing Plant, however. Much like the American Brewery, there was great support to save the historic structure and revitalize a neighborhood. This plan was developed and carried out in 2004 by Obrecht Real Estate and Struever Brothers, Eccles and Rouse and involved the $120-million redevelopment of the old National and Gunther plants, occupying 20 acres on Brewer's Hill in Canton. The architecture of the breweries was honored, as was their brewing legacy, seen here. The architect firm was the same that was used by Humanim at the American Brewery, Cho Ben Holback and Associates, guaranteeing the uncompromising historical integrity of the renovation. Today, the site is a combination of apartments, offices, retail space, and Bravo Health Care. As predicted, the neighborhood has benefited from the revitalization of the plants. (Both, author.)

National Brewing Company's legacy has lived on historically in Baltimore, even though the beer has not been brewed in Baltimore since 1996. After Stroh closed the Baltimore plant, the company struggled, and it was taken over by Pabst Brewing in 1999. By 2001, Pabst was taken over by Miller Brewing Company. National was no longer brewed in Pennsylvania but in Eden, North Carolina. Pabst still existed within the corporate structure of Miller, and hope was on the horizon. In 2010, the Pabst brands were sold to a Connecticut-based corporation that wanted to market beer in the local communities. In February 2011, Natty Boh was back on tap in bars throughout Baltimore for the first time since 1996. Natty Boh may no longer be produced in Baltimore, but his winking eye will continually watch over the city and its loyal followers. (Author.)

Another landmark associated with brewing was the American Can Company. The decades-old company was forced to consolidate and shut down the plant in 1986. For more than half a century, the American Can Company was an unmistakable Baltimore structure. Like American Brewery and Brewer's Hill, American was saved from the wrecking ball by savvy development and homage to the legendary company that created the first beer can. (Author.)

In the face of the many setbacks dealt to the brewing industry in the 20th century, locals clearly supported the craft in Baltimore. In addition, advocacy organizations like the Brewer's Association of Maryland, founded in 1996, were formed to promote and lobby for local craft brewers (like the ones at right) throughout the state. The Master Brewers Association of America supports and protects the breweries at the national level. (Author.)

The first place that every Baltimore native turns to for the latest release of any local beer is Max's Tap House. Max's is an iconic Fell's Point bar that carries the largest selection of beers in Baltimore and is the first place local breweries will release their fine concoctions. The bar proudly sponsors events from local brewers as well as national brewers. It is a true neighborhood gathering place to enjoy the brewing heritage of Baltimore, its German roots, and its various incarnations in America. Representative of this tradition, taps can be found throughout the tap house from draught beers past and present the world over. In February 2011, Max's was finally able to replace one tap gathering dust for 15 years: National Bohemian. (Both, author.)

The colorful history of brewing in Baltimore serves as both a reminder of the city's strong heritage and a testament to the craft brewing industry's ability to persevere with local support, despite the odds. In recent decades, many new breweries, like White Marsh Brewing in Baltimore County, have created a strong core of consumers, enabling success despite limited distribution. New breweries are opening regularly in and around the city in response to the demand for local quality craft brews. Although the technologies have changed, the craft itself is still an art form. The influences upon the brewers of these fine beers cannot be underestimated, as the flavors and styles grow increasingly complex, flavorful, and refreshing. It is clear that all of the brewers have one thing in common—whether a success or failure, they truly understand and embrace the deeply rooted tradition of brewing in Baltimore. (Author.)

BIBLIOGRAPHY

Baltimore Past and Present: 1887 United States Brewers Association Convention Program. Baltimore: Morling, Mykr & Co., Printers and Publishers, 1887.

Bastian, C., D.M. Oakley-Simpson, D.J. Menkhaus, D.M. McLeod, J. Ogden, G.D. Whipple, J. Woirhaye. *Malt Preferences of the Craft Brewing Industry.* Wyoming: USDA, October 1998.

"Brewing in Baltimore." *The Western Brewer: and Journal of the Barley, Malt, and Hop Trades.* vol. 12 (May 15, 1887): 1012.

Down, William L. *Dictionary of the History of the American Brewing and Distilling Industries.* Westport, CT: Greenwood Press, 1980.

Ford, Everett and Janice. *Pre-Prohibition Beer Bottles and Breweries of Baltimore Maryland.* Baltimore: Paul M. Harrod Co., 1974.

Haire, Kelvin. "McHenry Brewing Founder Prepared to Dive Right on In." *Baltimore Business Journal* August 18, 1994: 12–18.

Kelley, William J. *Brewing in Maryland.* Baltimore: William J. Kelley, 1965.

Ketchum Jr., William C. *A Treasury of American Bottles.* New York: Rutledge, 1975.

Logan, Harold, and Donald Baker. "Wine and Beer Occupy Some Members of the Maryland General Assembly; Measure to Legalize Homemade Beer Is Voted by Md. Panel; Legal Homemade Brew is Backed." *Washington Post* March 4, 1977.

National Wholesale Liquor Dealers Association of America. *The Anti-Prohibition Manual: A Summary of Facts and Figures Dealing with Prohibition.* Cincinnati: NWLDA, 1916.

Schaefer Beer: One of Baltimore's Leading Export Cargoes. Baltimore: Port of Baltimore, 1973.

US Census Bureau. *Eleventh Census: 1890 Report on Manufacturing.* Part II: 46–57. Washington, DC: US Census Bureau, 1890.

US Department of Commerce. *Historical Statistics of the United States, Colonial Times to 1970.* Parts 1 and 2. Washington, DC: US Census Bureau, 1975.

Vogel, Robert M., ed. "The Physical Presence of Baltimore Engineering and Industrial History: A guide for Tourists." *Society for Industrial Archaeology: Some Industrial Archaeology of Monument City and Environs* April 1975.

DISCOVER THOUSANDS OF LOCAL HISTORY BOOKS FEATURING MILLIONS OF VINTAGE IMAGES

Arcadia Publishing, the leading local history publisher in the United States, is committed to making history accessible and meaningful through publishing books that celebrate and preserve the heritage of America's people and places.

Find more books like this at
www.arcadiapublishing.com

Search for your hometown history, your old stomping grounds, and even your favorite sports team.